SAN ANTONIO IN COLOR

SAN ANTONIO IN COLOR

PAINTINGS *by* W.B. THOMPSON

with San Antonio Highlights by Jenny Browne

TRINITY UNIVERSITY PRESS, SAN ANTONIO

Published by Trinity University Press
San Antonio, Texas 78212

Printed in China
Photographs of paintings by Ansen Seale, Seale's Studios Inc., San Antonio, Texas
♾ The paper used in this publication meets the minimum requirements of the
American National Standard for Information Sciences—Permanence of Paper
for Printed Library Materials, ANSI Z39.48-1992.

Library of Congress Cataloging-in-Publication Data

Thompson, W. B. (William B.), 1966–
San Antonio in color / paintings by W. B. Thompson; with San Antonio highlights by Jenny Browne
 p. cm.
ISBN 1-59534-002-5 (alk. paper) — ISBN 1-59534-003-3 (pbk. : alk. paper)
1. Historic sites—Texas—San Antonio—Pictorial works. 2. City and town life—Texas—San Antonio. 3. City
and town life in art. 4. San Antonio (Tex.)—Pictorial works. 5. San Antonio (Tex.)—Quotations, maxims, etc.
6. San Antonio (Tex.)—Social life and customs. I. Browne, Jenny. II. Title.
F394.S21143T48 2004
976.4'351064—dc22 2004008789

08 / 5 4 3 2

Book and jacket design by DJ Stout and Drue Wagner, Pentagram, Austin, Texas

This book is dedicated to Talisse,
who was born on a rainy day in
January 2000 in San Antonio.

I consider San Antonio my artistic birthplace. I began painting in large part due to the encouragement of art professor Bill Bristow and the Trinity University community. My early paintings focused on San Antonio's cloistered beauty. I also gained historic and aesthetic perspective from time spent at the McNay Art Museum and life drawing sessions at the Coppini Academy in San Antonio. Patronage and shows at Cappy's Restaurant gave me a venue to share my early paintings.

Over the years I have painted many of the city's cultural icons and landmarks. Preparing paintings for this book allowed me to retrace my early footsteps as a young artist and was both a retrospective and a vanguard for me. My painting sense and style have evolved, but San Antonio's people, architecture, river, festivals, and flora and fauna have

been my muse. As my quixotic life as a painter continues, I know that my artistic lineage will always be a fundamental part of my heart and my art.

Thanks to Lori, my true muse and love; my parents, Annemarie and William Thompson Sr.; Lisa and Bryan Parman; Cappy and Suzy Lawton; Bill and Wilanna Bristow; Denise Barron and Jerry Hayes at Artistic Endeavors; Jane Coombs at Mango Tango Gallery in St. Thomas; Mary Denny; Char Miller; Barbara Ras; Sarah Nawrocki; Gerry Lair; Brad Parman; Robert Layton at RDL Associates; the Olmos Pharmacy and its huevos rancheros and milkshakes; and the entire Trinity University community.

W. B. Thompson

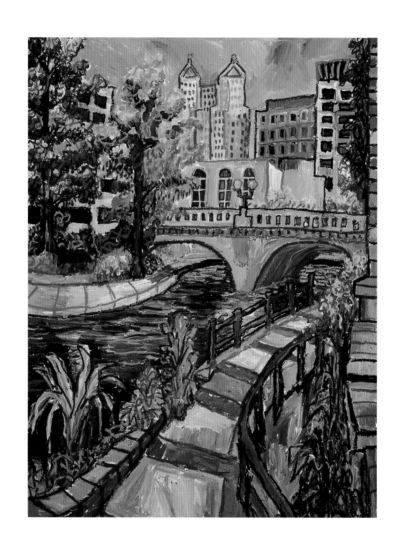

SOUTH SIDE RIVER WALK PASSAGE

We marched five leagues over
a fine country, with broad plains —
the most beautiful in New Spain.
We camped on the banks of an
arroyo, adorned by a great number
of trees, cedars, willows, cypresses,
osiers, oaks and many other kinds.
This I called San Antonio de Padua,
because we reached it on his day.

Domingo Terán de los Rios

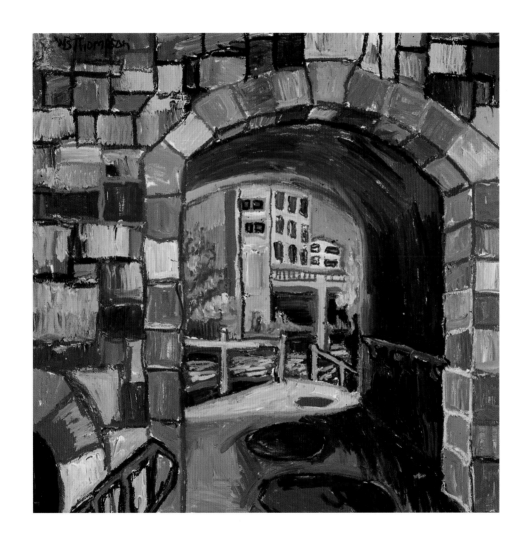

LOW ARCHED BRIDGE

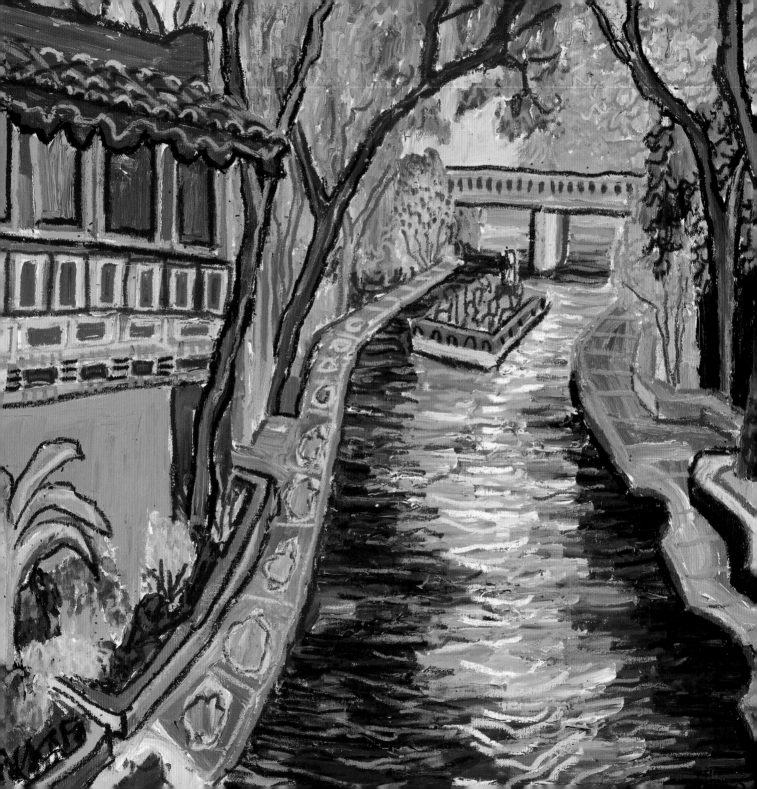

Its water is usually of a lovely milky-green. The stranger strolling on a mild summer day often finds himself suddenly on a bridge, and is half startled with the winding vista of sweet lawns running down to the water, of the weeping-willows kissing the surface, of summer-houses on its banks, and of the swift yet smooth-shining stream meandering this way and that.

Sidney Lanier

OLD CHINESE RESTAURANT

What phantasmagoric gully
was that stream beneath our
window, lined along its curling
course with what inconceivable
multitudes? What shapes were
those on the water passing by,
those drifting baubles of light
and color, those gesticulating
figures weirdly dressed?

Jan Morris

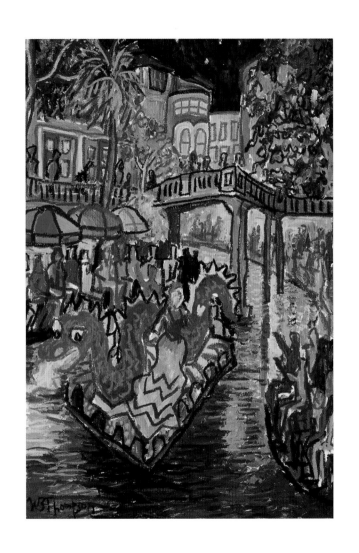

FIESTA NIGHT RIVER PARADE

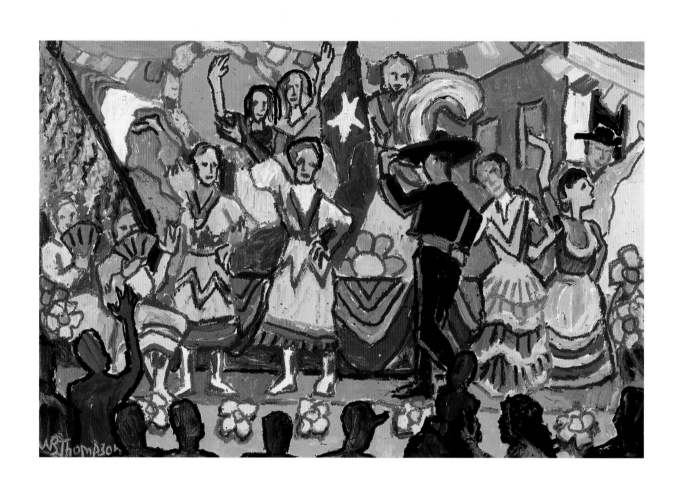

FIESTA PARADE FLOAT WITH DANCERS

After the vehicles and floats
had circled the plaza, they drew
up before the old battle-scarred
mission-church and threw their
floral offerings at its front.

San Antonio Express-News, *on the*
1902 Battle of Flowers Parade

Every city lucky enough to
be on a river ought to take
as its model San Antonio.

Charles Kuralt

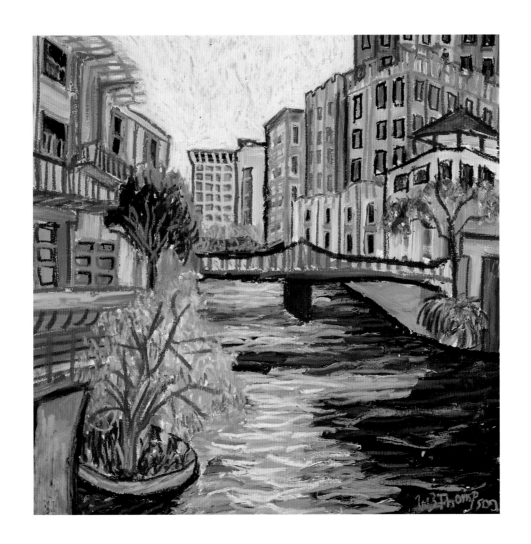

VIEW TO PRESA BRIDGE

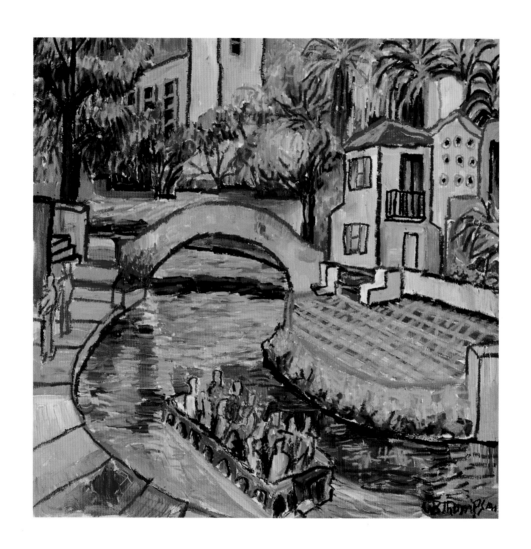

ARNESON RIVER THEATER

San Antonio is like Quebec, a city of the olden time, jostled and crowded by modern enterprise. . . . Walking about the city and its environs you may well fancy yourself in some foreign land. . . . The narrow streets, the stout old walls which seem determined not to crumble away.

Richard Everett

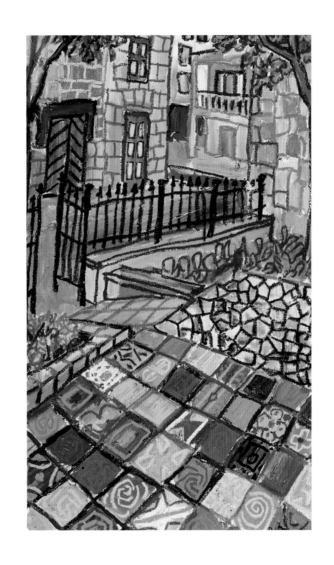

LA VILLITA MOSAIC

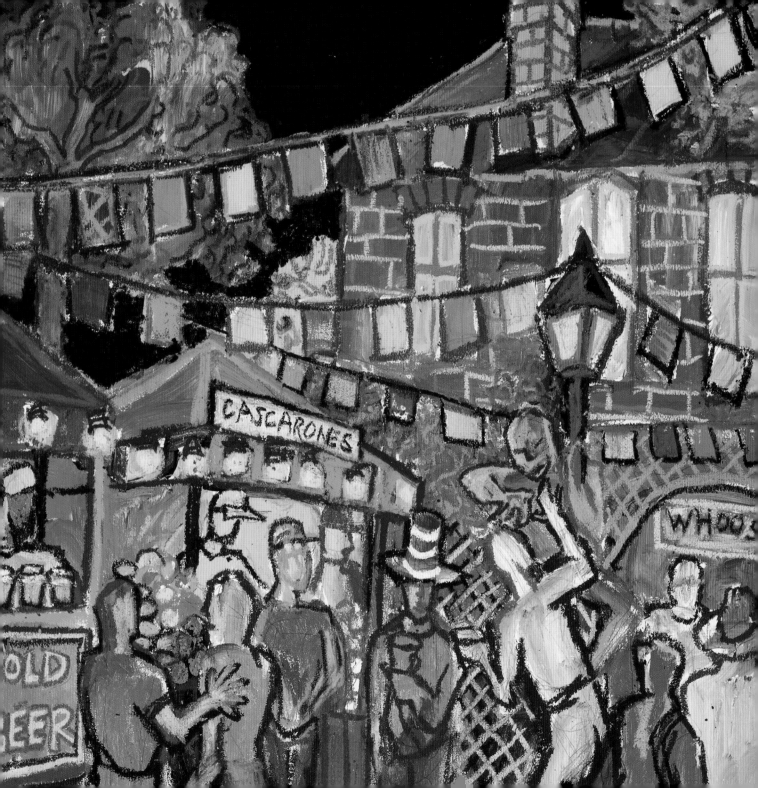

San Antonio, not one town,

but a collection of towns, is still

easy-going, festive, cosmopolitan,

far from any other oasis. . . .

And thanks to the influence of

the Latin spirit. . . . life on the

streets is diverting.

Charles Ramsdell

CASCARÓN BAPTISM

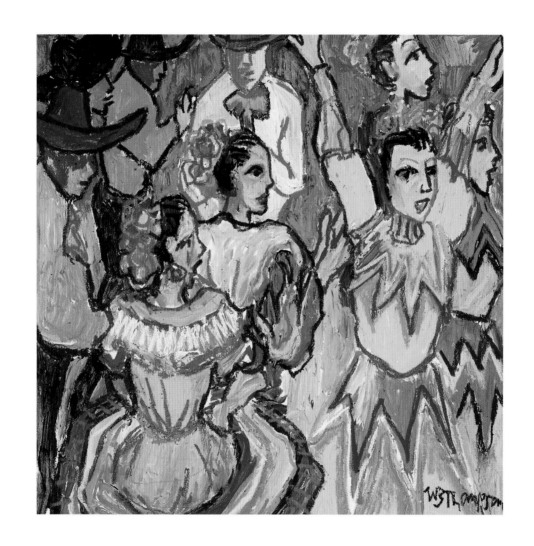

FESTIVAL DANCERS

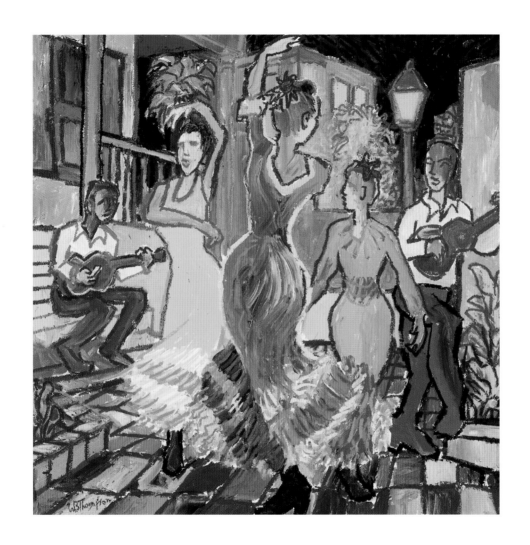

FLAMENCO DANCERS

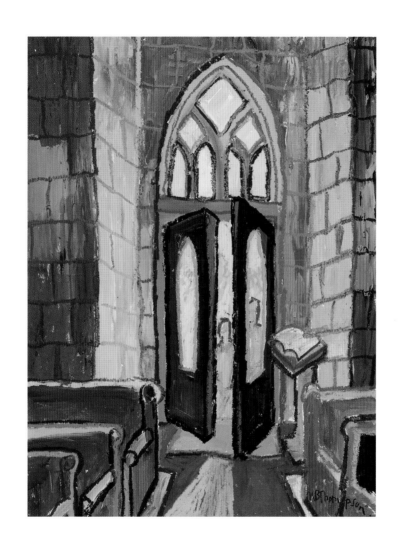

LITTLE CHURCH OF LA VILLITA

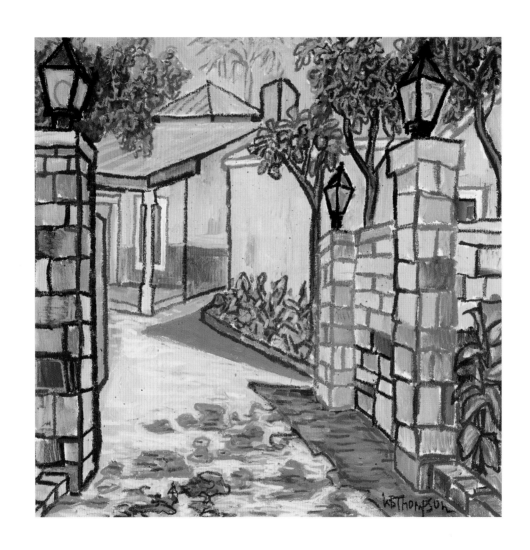

GATE TO LA VILLITA

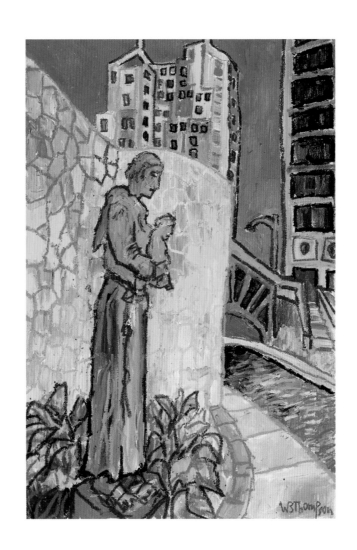

ST. ANTHONY STATUE

The San Antonio river is formed by about one hundred large springs in a beautiful valley four miles above the city. Many of these springs would singly form a river; and when they unite in the San Antonio, they form a bold and rapid stream of two hundred feet in width, and about four feet deep over the shoals.

George Bonnell

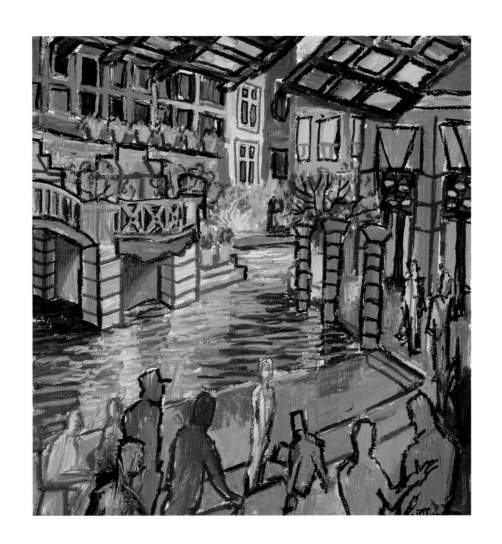

RIVERCENTER MALL

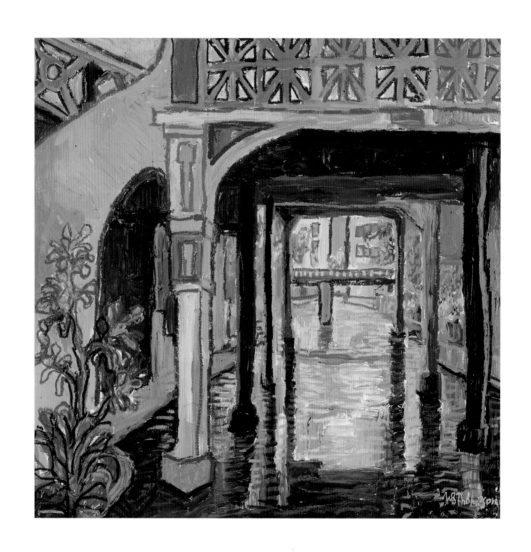

UNDER COMMERCE STREET

One may take one's stand on the Commerce Street Bridge and involve oneself in the life that goes by this way and that. Yonder comes a long train of enormous blue-bodied, canvas-covered wagons, built high and square in the stern, much like a fleet of Dutch galleons, and lumbering in a pondering way that suggests cargoes of silver and gold.

Sidney Lanier

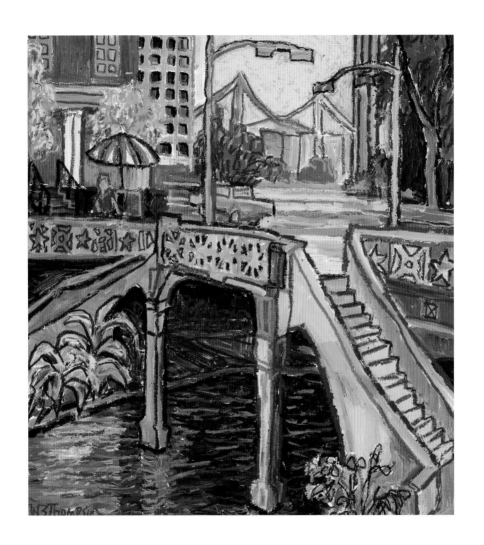

RASPA CART

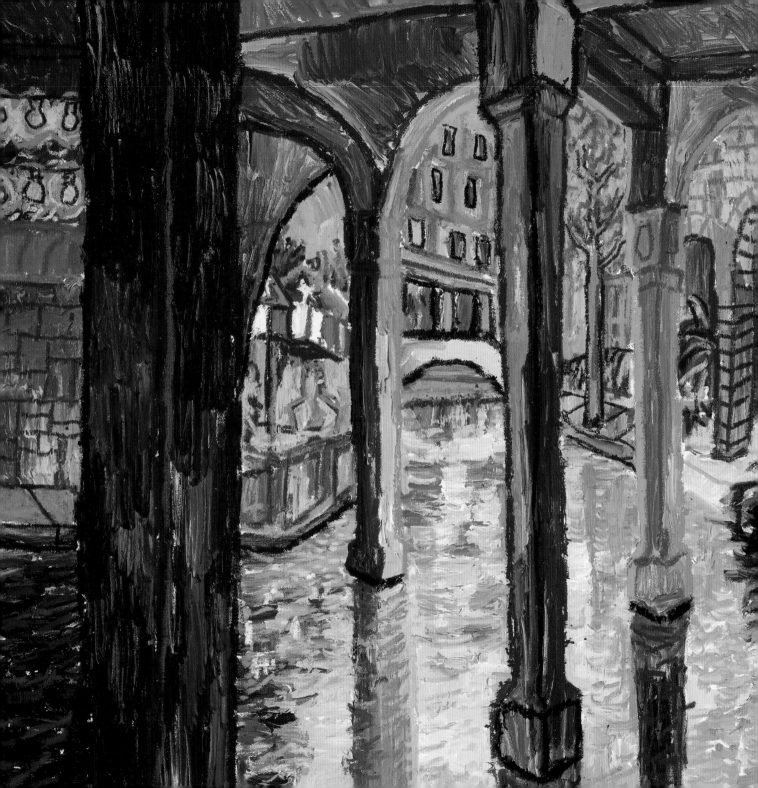

They came for the water,
came to its sleeping place
here in the bed of an old sea,
the dream of the water.

Rosemary Catacalos

UNDER THE BRIDGE

From all manner of people there
came an exhibition of profound
affection for San Antonio. It seemed
to symbolize for them the poetry
of life in Texas.

Stephen Crane

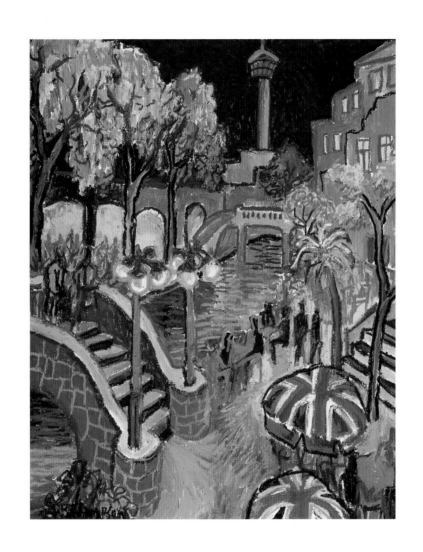

KANGAROO COURT

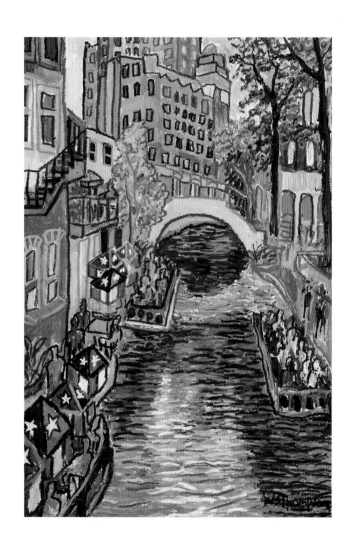

CASINO BUILDING

Strolling up the river a quarter of a mile, one comes upon a long white stone building which has evidently had much trouble to accommodate itself to the site upon which it is built, and whose line is broken into four or five abrupt angles, while its roof is varied with dormer-windows and sharp projections and spires and quaint clock-faces, and its rear is mysterious with lattice-covered balconies and half-hidden corners and corridors.

Sidney Lanier

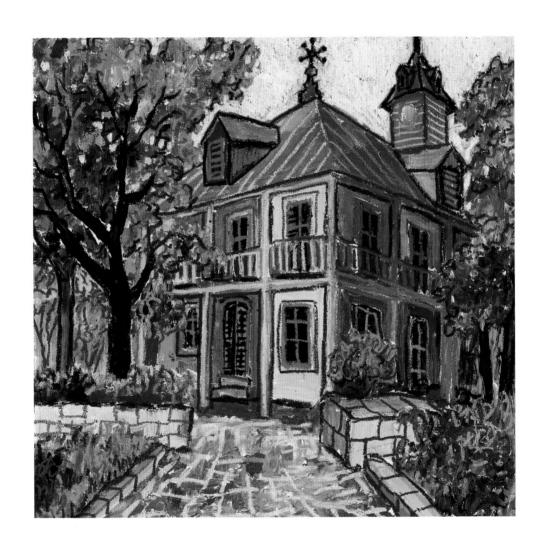

SOUTHWEST SCHOOL OF ART & CRAFT

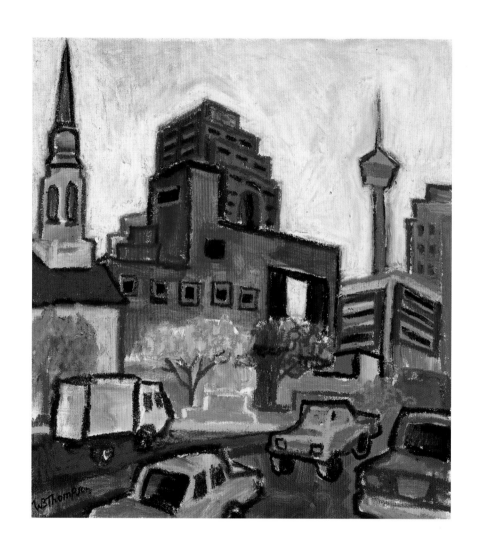

CENTRAL LIBRARY

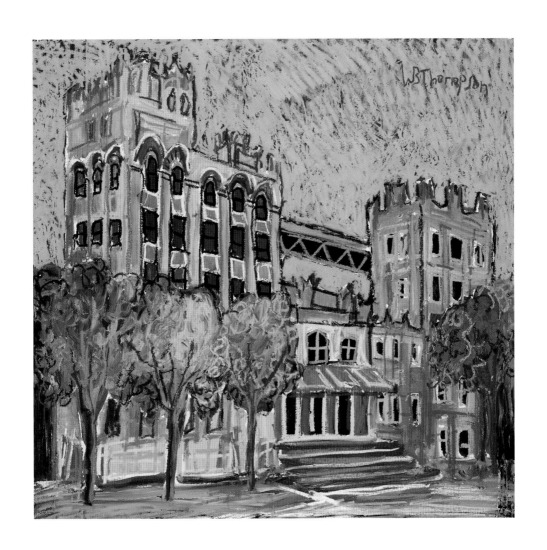

SAN ANTONIO MUSEUM OF ART

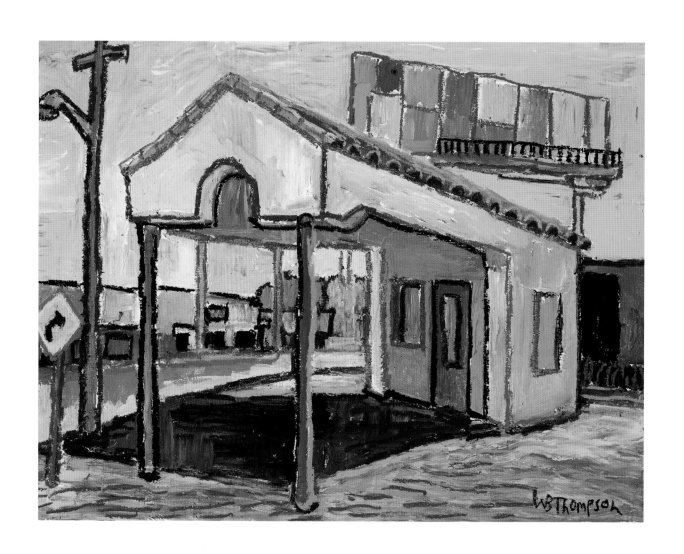

NORTH ST. MARY'S STREET GAS STATION

Suddenly, we were in absolutely tropical heat at the bottom of a five-mile-long hill, and up ahead we saw the lights of old San Antonio. You had the feeling this all used to be Mexican territory indeed. Houses by the side of the road were different, gas stations beater, fewer lamps.

Jack Kerouac

In many respects we Americanize the Germans—but in one respect the Germans are rapidly Germanizing the Americans. The Americans are rapidly acquiring a taste for the national beverage of Germans—beer.

San Antonio Herald, *February 23, 1877*

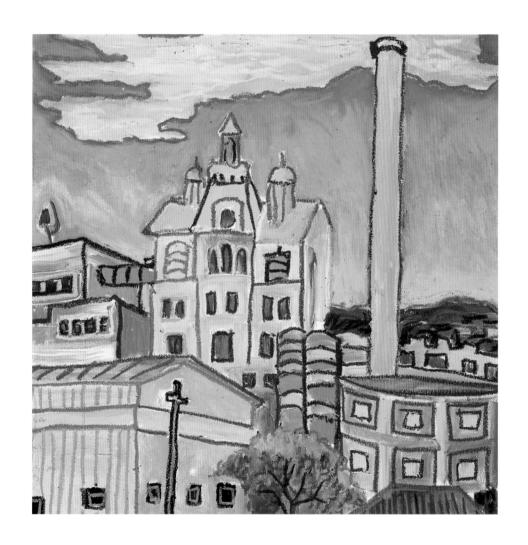

PEARL BREWERY

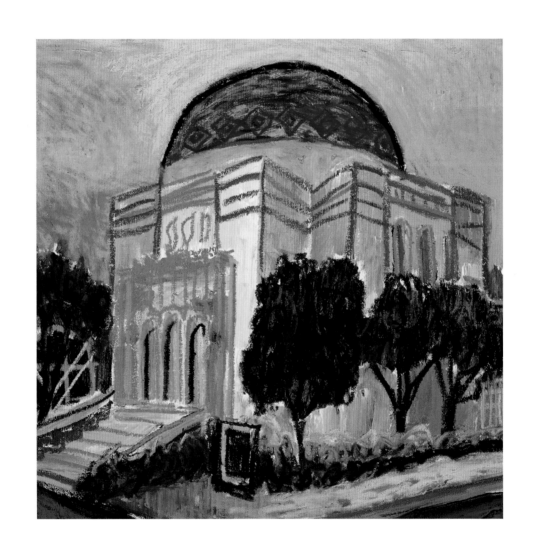

TEMPLE BETH-EL

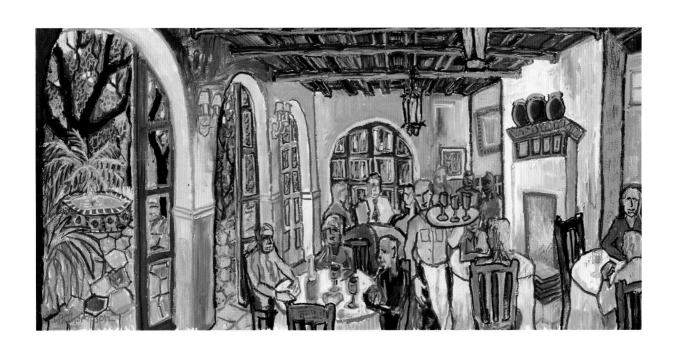

DINING IN SAN ANTONIO

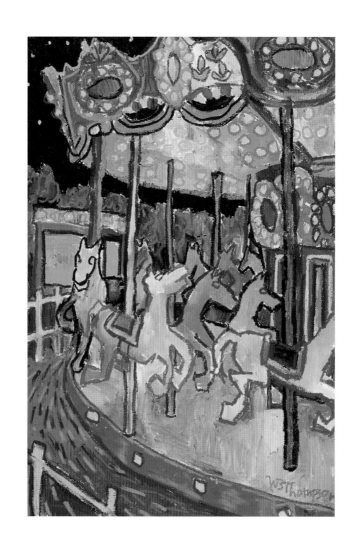

BRACKENRIDGE PARK CAROUSEL

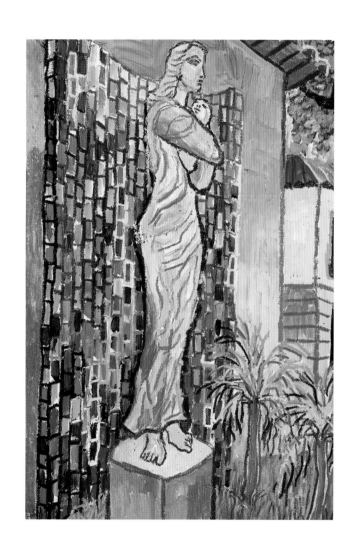

WITTE SCULPTURE
Mother and Child

59

San Antonio. . . is, next to
San Francisco, New Orleans,
and possibly Boston, the most
colorful, the most "romantic"
city in America.

John Gunther

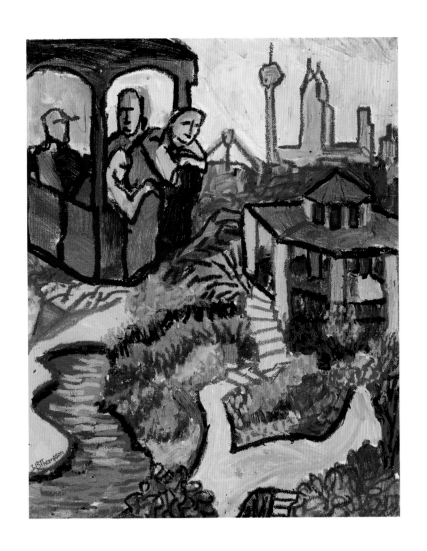

JAPANESE TEA GARDEN

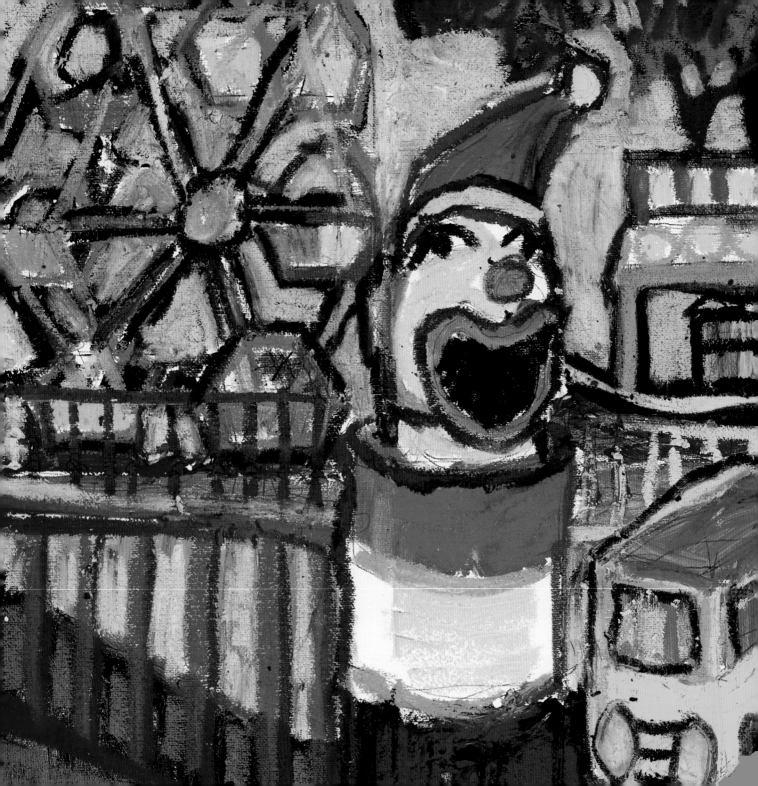

GARBAGE CAN AT KIDDIE PARK

San Antonio. . . is a city where much of the past seems alive. This has fostered a mystique rare in America, a feeling of living on historic, even sacred ground.

T. R. Fehrenbach

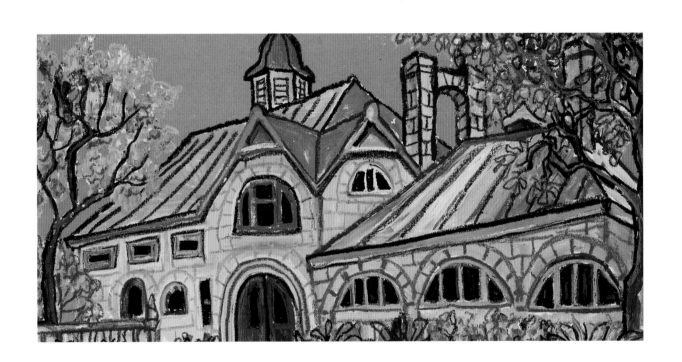

SAN ANTONIO BOTANICAL GARDEN

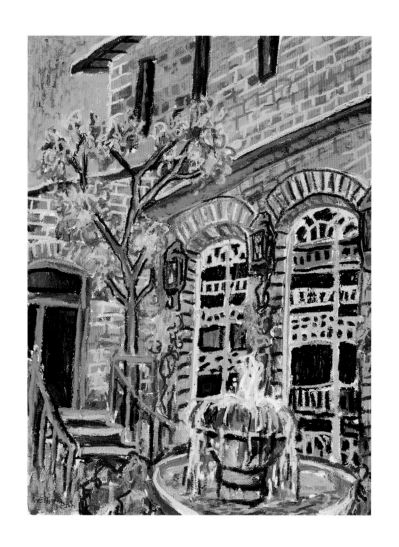

TRINITY CHAPEL

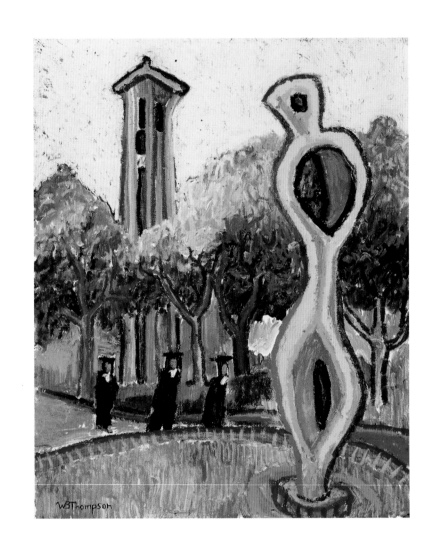

TRINITY TOWER

Large Interior Form

Outsiders visiting San Antonio visit San Antonio because they expect to see something of distinction, something of charm. They should see the most distinctive campus in the country in Trinity University: informal, definitively Texas, picturesque, charming, yet functional, living, useful.

Bartlett Cocke

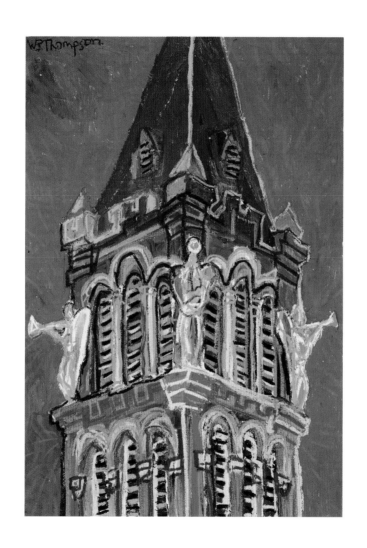

MOTHERHOUSE
University of the Incarnate Word

CHILE PEPPERS

Central Market

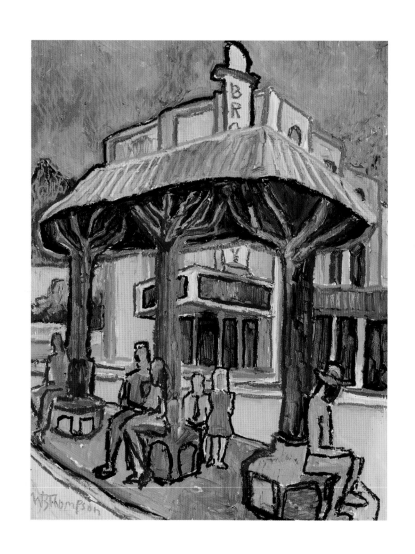

ALAMO HEIGHTS BUS STOP

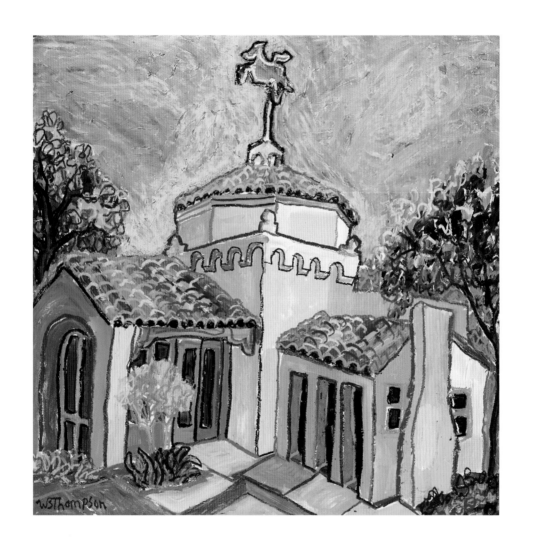

OLD GAS STATION

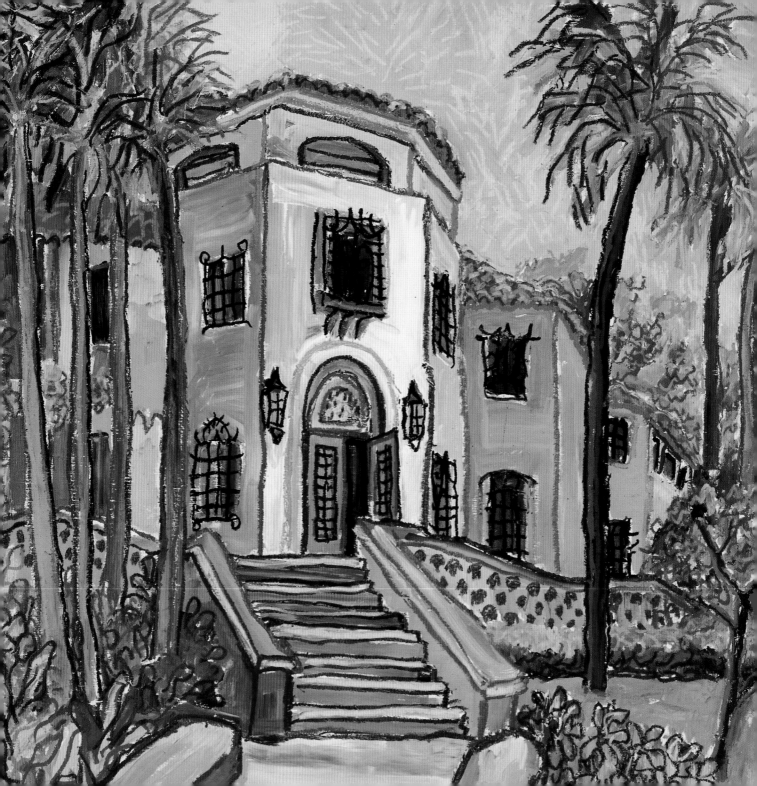

McNAY ART MUSEUM

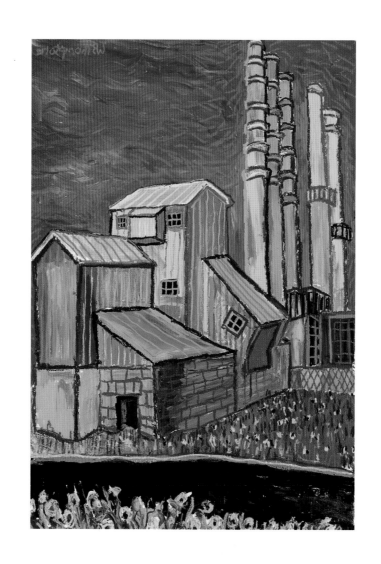

ALAMO CEMENT COMPANY

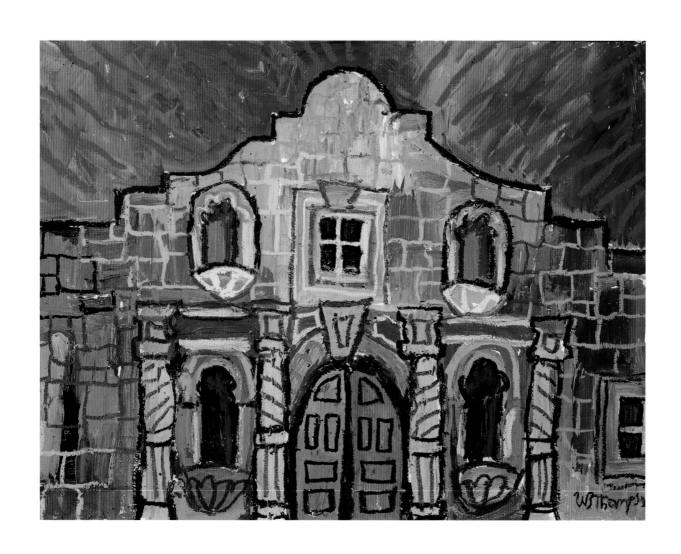

ALAMO

The memories that cling around the Alamo are of such a nature that they demand more than a passing recognition. Nor are they bound within the narrow limits of this city, section or state. The Acts of which it is or should be the lasting memorial, are the common property of all lovers of liberty—a birthright upon which all have a claim, of whatever class, creed or race.

San Antonio Express, *January 16, 1877*

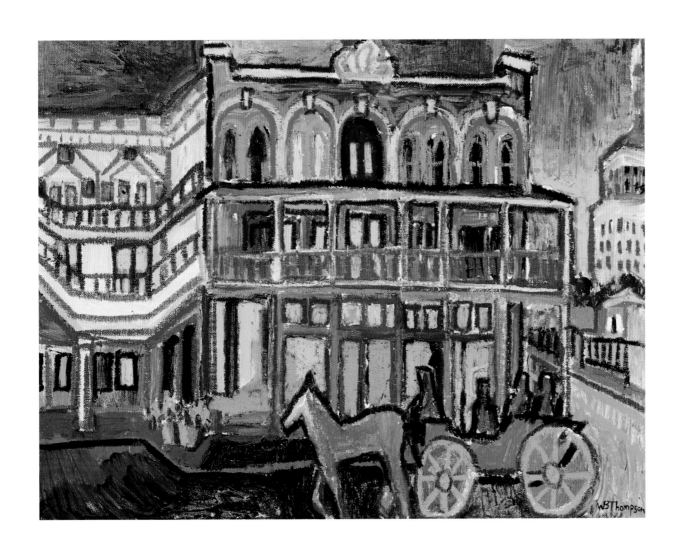

FAIRMOUNT HOTEL

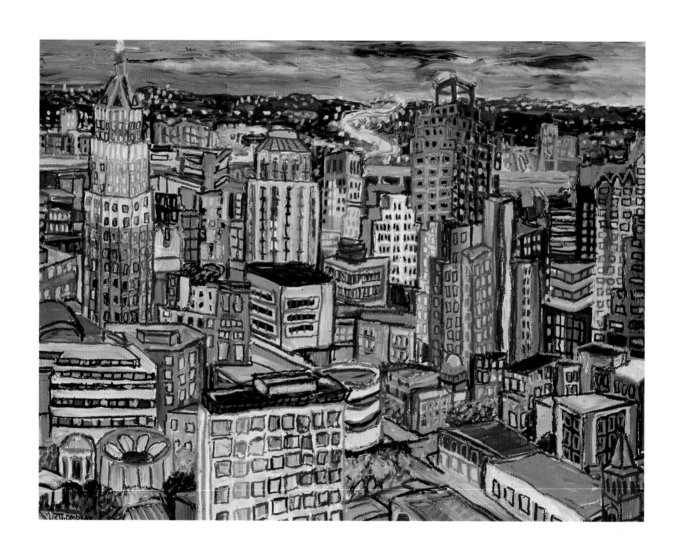

VIEW FROM TOWER OF THE AMERICAS

More than most cities, though, San Antonio holds on to its past. That's why it is called, rightly or wrongly, "one of the four unique cities in America."

Claude Stanush

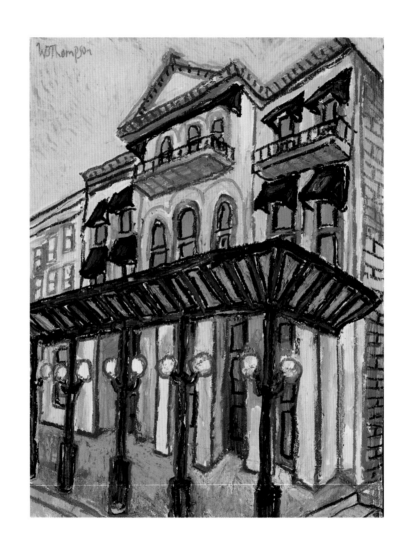

MENGER HOTEL

Our hospitium, or Inn, the Menger, everyone knows, or is himself unknown, is an excellent one — The apartments, including the dining saloon, are good, and the cuisine soignée. In this latter point, the Menger is excellent and in civility and attention the waiters have the advantage of most Hotels.

San Antonio Herald, *December 6, 1871*

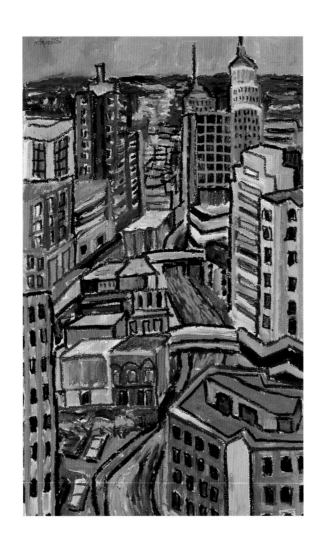

TWENTY FLOORS UP

Whether your residence is Wizard Wells or Waco or Wichita Falls, you have another love always, which is San Antonio. It's kind of like that other woman or other man that you remember from your high school days, that you never quite surrender. And no one surrenders San Antonio, which is one of the memorable cities in the United States.

Joe B. Frantz

San Antonio . . . is of Texas, and yet it transcends Texas in some way, as San Francisco transcends California, as New Orleans transcends Louisiana.

Larry McMurtry

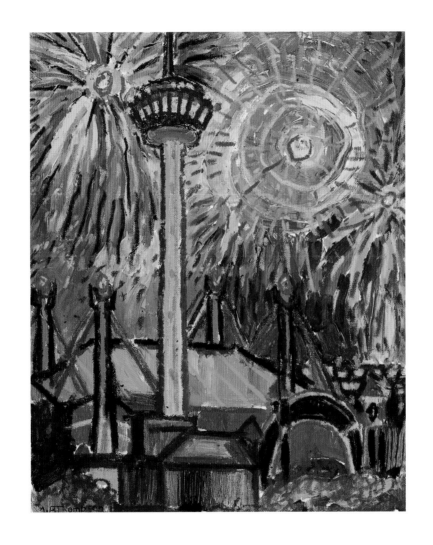

FIREWORKS

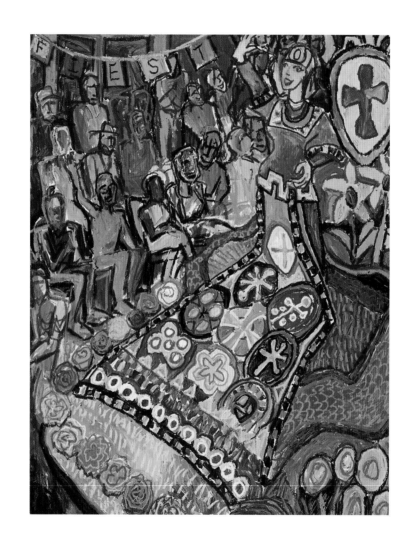

FIESTA ROYALTY

The talk of the town seemed . . .
of Ugly Kings and Fabergé Courts,
of Cavaliers and Coronations, of
curtseying instructions and
sixty-thousand [dollar] dresses.
The whole city seemed seized in an
arcane ecstasy all its own, jumping
up and down with the excitement
of it, discussing nothing else.

Jan Morris

It was fragrant and soft—the softest
air I'd ever known—and dark, and
mysterious, and buzzing.

Jack Kerouac

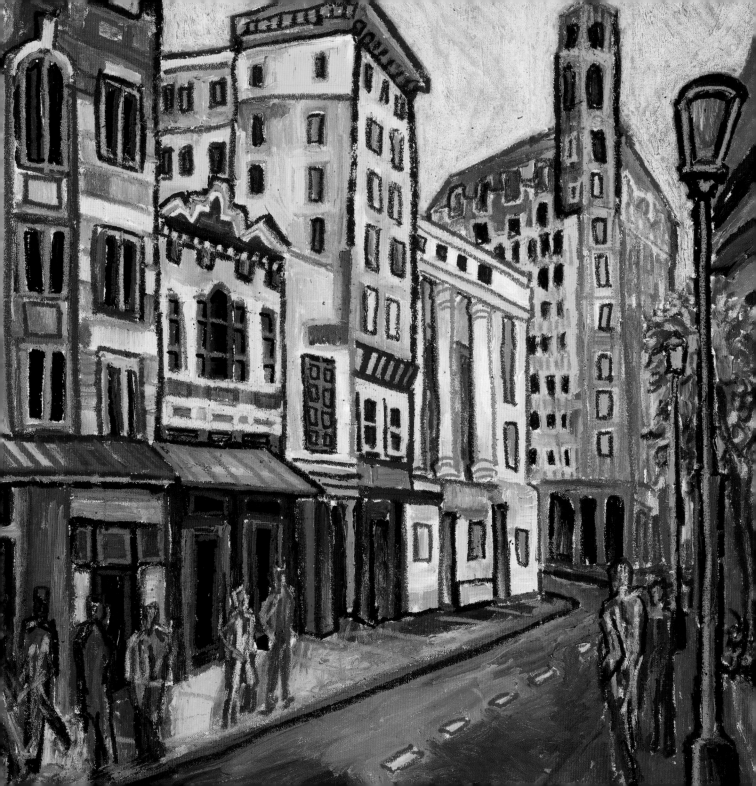

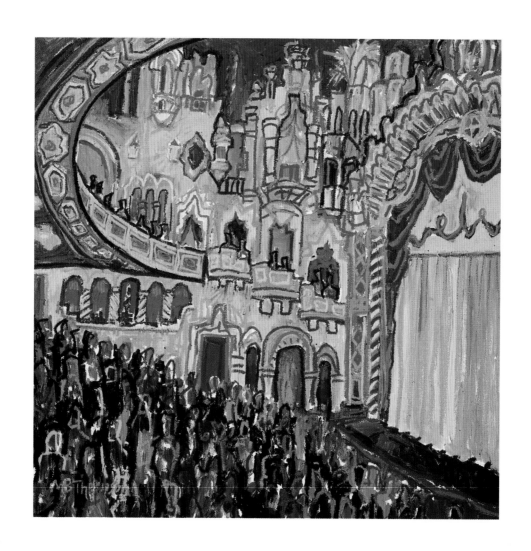

MAJESTIC THEATER

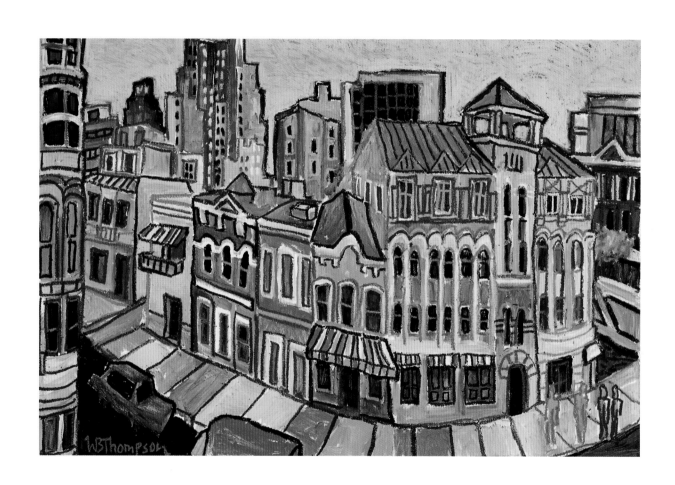

COMMERCE STREET SCENE

If peculiarities were quills, San Antonio de Bexar would be a rare porcupine. Over all the round of aspects in which a thoughtful mind may view a city, it bristles with striking idiosyncrasies and bizarre contrasts. Its history, population, climate, location, architecture, soil, water, customs, costumes, horses, cattle, all attract a stranger's attention, either by force of intrinsic singularity or of odd juxtaposition.

Sidney Lanier

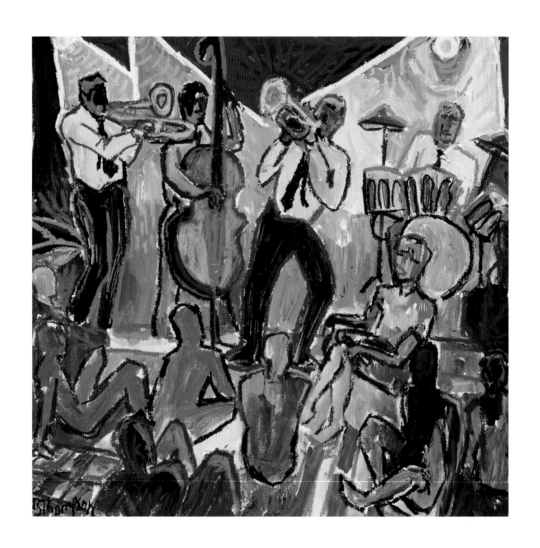

JAZZ'S ALIVE

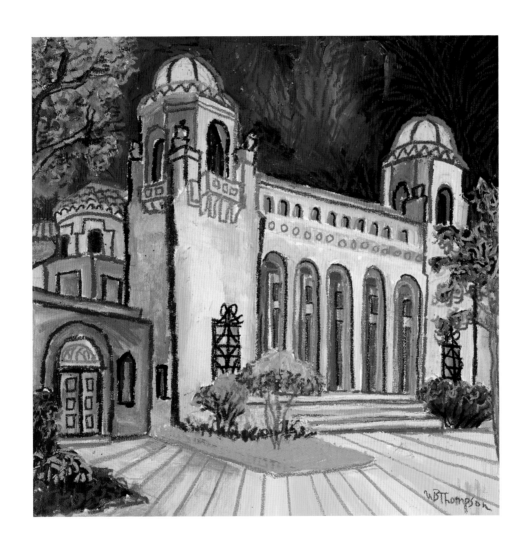

MUNICIPAL AUDITORIUM

The San Antonio River is wound cunningly through the town like a pattern of a valentine (does it make a heart?) with little waterfalls and ferny banks. . . . You have the sensation in San Antonio by day of the world's being deliciously excluded.

Graham Greene

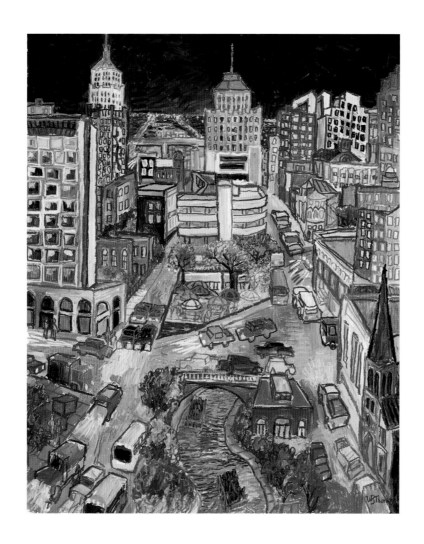

TRAFFIC PATTERNS

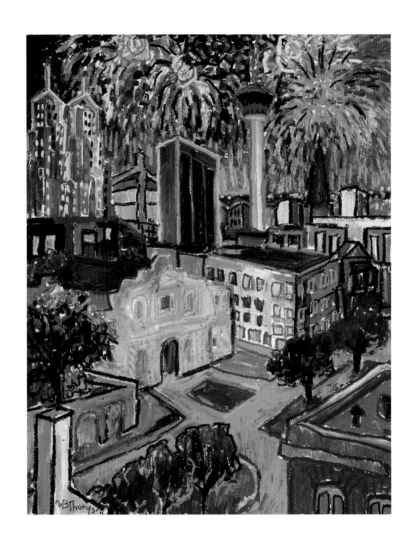

FIREWORKS OVER HEMISFAIR

Coming to San Antonio for my birthday is like coming back home. I guess there isn't a city or town in the whole world that holds more happy memories for me.

Dwight D. Eisenhower

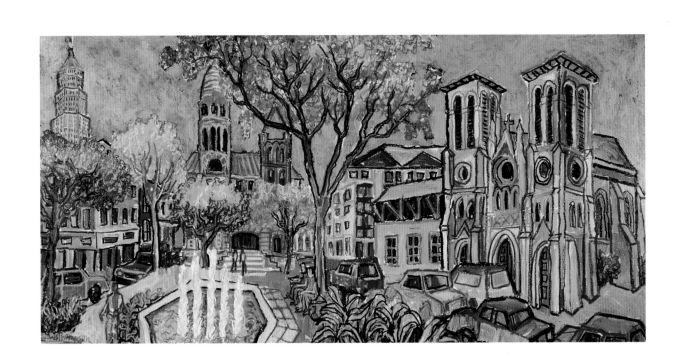

SAN FERNANDO CATHEDRAL

From the earliest days of settlement and throughout the colonial era and beyond, history and travel in Texas converged on the two plazas between which San Fernando stands. As the population grew, these two modest squares of land throbbed with trade and commerce, government, festivity and pageantry, skirmish and tumult, and the quieter tempos of town life. And over all this hubbub, decade after decade, the bells of San Fernando long rang out to mark baptisms, weddings, funerals, and the daily call to worship.

Mary Ann Noonan Guerra

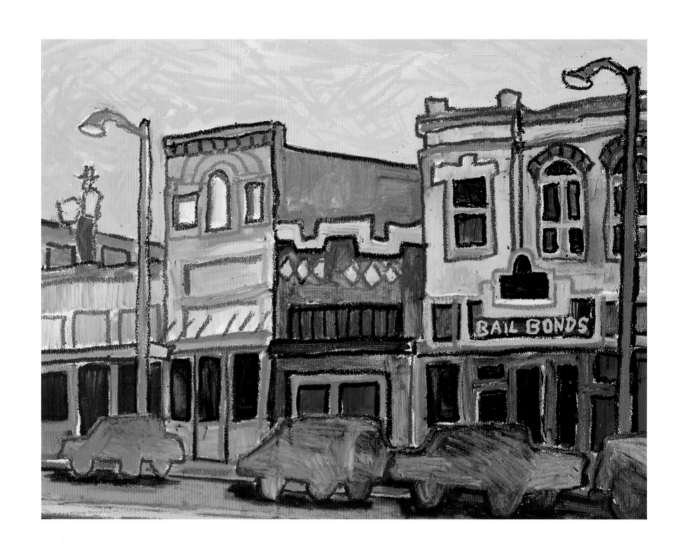

CITY STOREFRONTS

San Antonio in 1900 was a city of contrasts, a wide-open frontier town, a city of southern hospitality and racial deference, a gateway to Mexican culture, a symbol of Texas pride and tradition, a military center, and a booming urbanizing city.

Richard A. Garcia

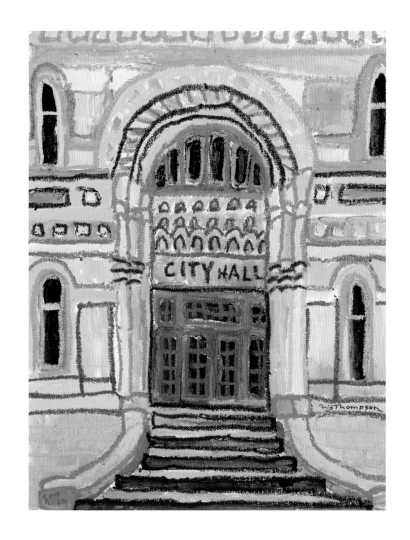

CITY HALL

We get to San Antonio in the early
afternoon. . . . We drive past streets
named Picoso, Hot and Spicy Street;
Calavera, Skeleton Street; and
Chuparrosa, Hummingbird Street.
It's odd to see the names in Spanish.
Almost like being on the other side,
but not exactly.

Sandra Cisneros

SPANISH GOVERNOR'S PALACE

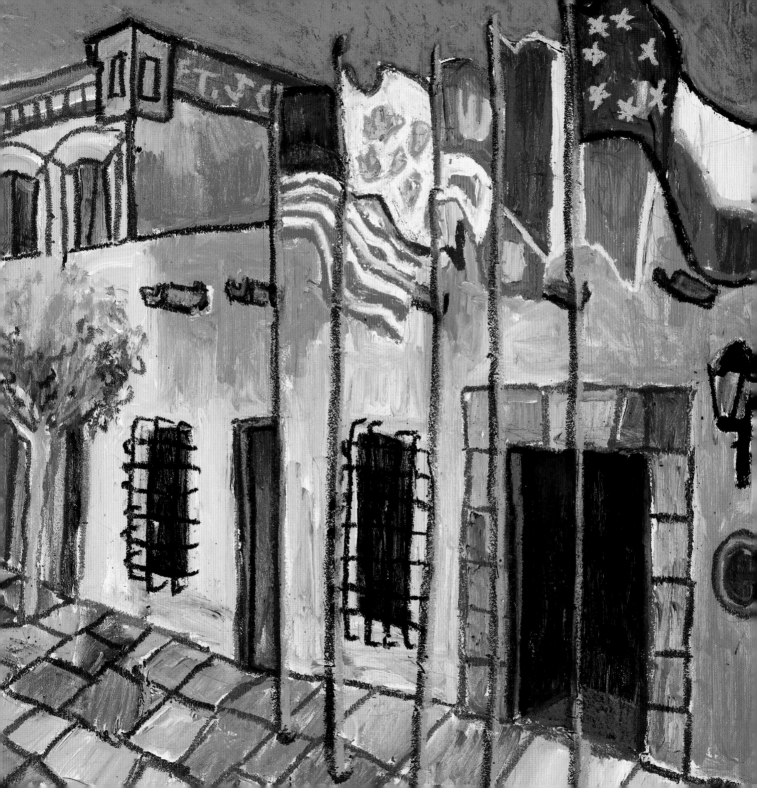

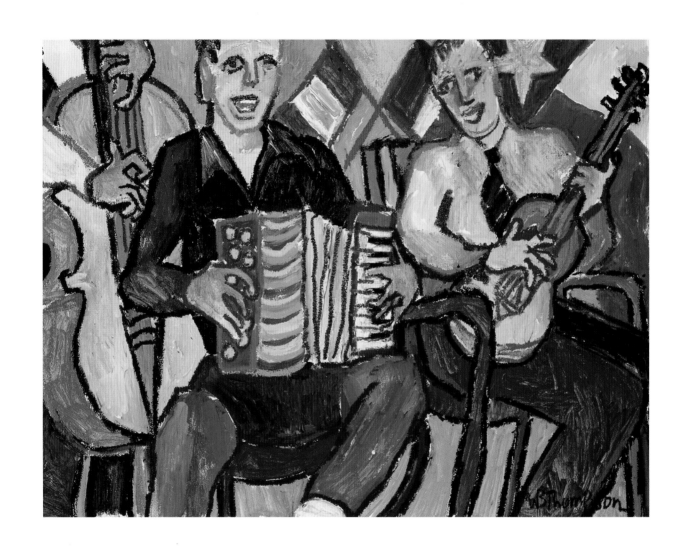

CONJUNTO PLAYERS

The music of the Mexican band breathes and moves and has its being like animate nature. It is as sweet as the lark's matin and as sensual as the wooing nightingale's call to its mate. It thunders in volume like the old ocean's roar and pulsates like the dying swan's last note. To hear it is a revelation, to analyze it is an education, to appreciate it is ennobling.

San Antonio Express, *October 6, 1890*

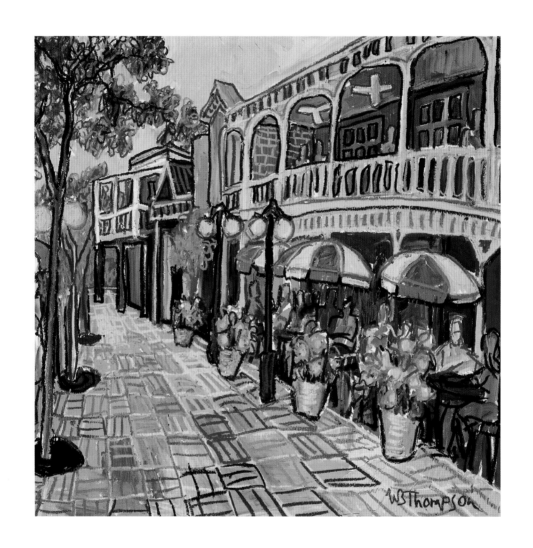

EL MERCADO

There's a lazy way about San Antonio, something in the air, the smell of Mexican food and sizzling beef drifting through restaurant doors, or at the Mercado, these aromas wafting heavy into the air while ranchera or norteña music plays.

Marian Haddad

DAYS OF THE DEAD

It was late afternoon one May day in 1974 when the distant voices of los antepasados were in the parched Texas scirocco wind that blew through San Fernando cemetery, feeling like a breath the planet exhaled thousands of years before. It was the same wind that had always been blowing through our lives. . . . A wind of story, a wind of forgetting, a perpetual wind, through storms and droughts and calorones that is a blessing from our ancestors.

John Phillip Santos

It was in San Antonio, however,

that I found more to please me. . . .

Those old Spanish churches, with

their picturesque remains and

dome and their handsome carved

stonework, standing amid the verdure

and sunshine of a Texas prairie,

gave me a thrill of strange pleasure.

Oscar Wilde

OUR LADY OF GUADALUPE CHURCH

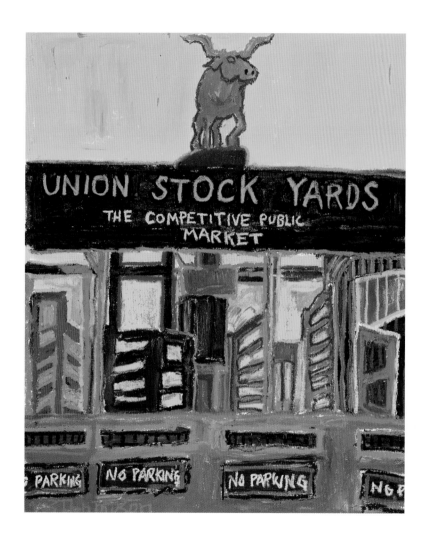

UNION STOCK YARDS

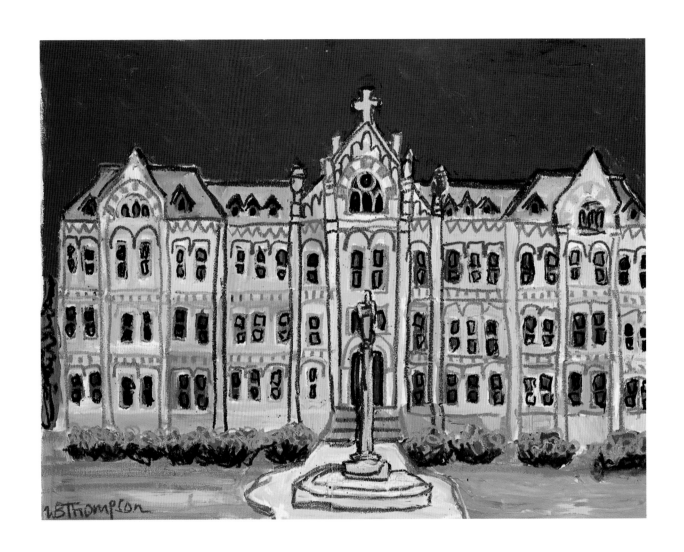

ST. MARY'S UNIVERSITY

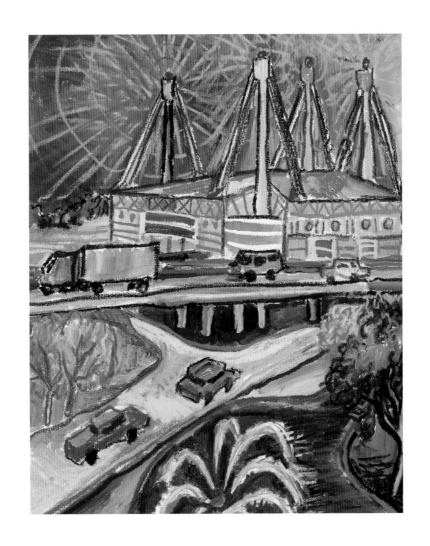

ALAMODOME

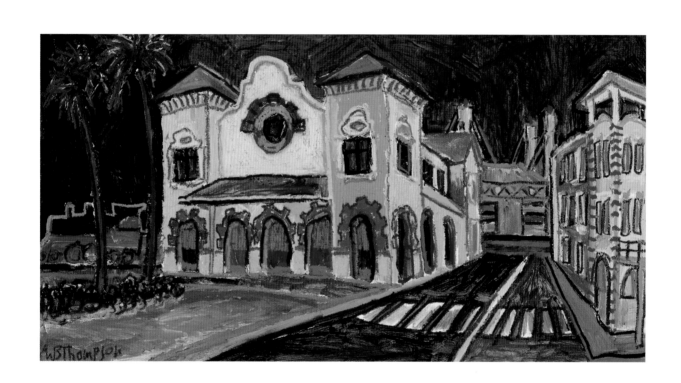

SUNSET STATION EXTERIOR

Yesterday morning, about 11 o'clock, the first through train from the far away Pacific Coast steamed into San Antonio at the Sunset depot. . . . It is impossible to foretell or approximate the great advantages San Antonio will derive from her central position on this great line between New York and San Francisco as it will undoubtedly open up for settlement and commerce a broad and fertile land.

San Antonio Express, *February 5, 1885*

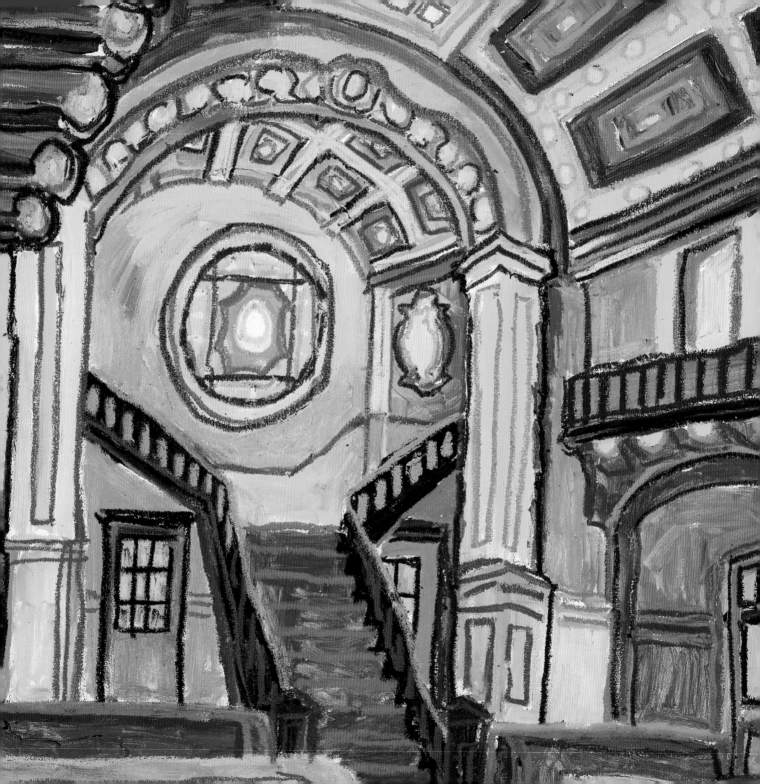

SUNSET STATION INTERIOR

C A R V E R A C A D E M Y

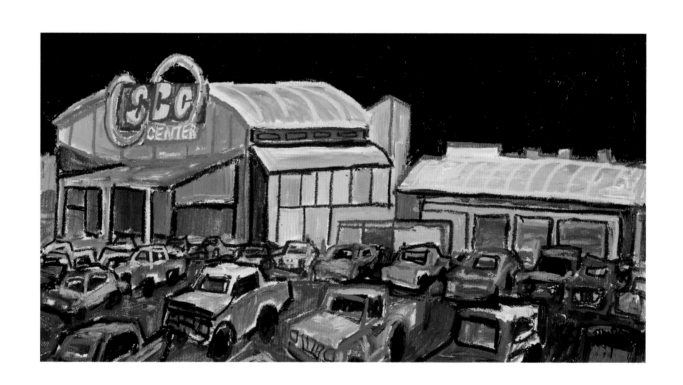

SBC CENTER

When we celebrate the championship everyone comes together and everyone is happy, and that's a great thing. How many times in a city do you see everyone on the same page? . . . That's a force for good.

David Robinson

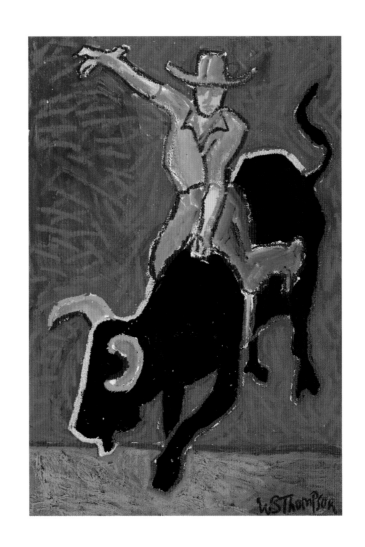

STOCK SHOW AND RODEO

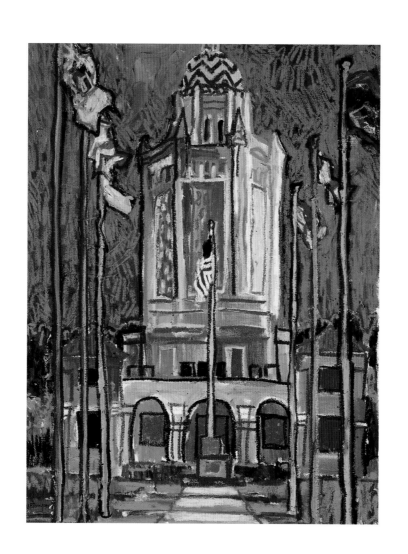

TAJ MAJAL

Randolph Air Force Base

158

So many young soldiers and officers have found wives in San Antonio that military men call it "The Mother-in-Law of the Army."

Green Peyton

Judge Noonan suggested it would
be a good idea for the county to sell
the courthouse for a vaudeville show,
as it is not fit for anything else.

San Antonio Express, *June 7, 1884*

BEXAR COUNTY COURTHOUSE

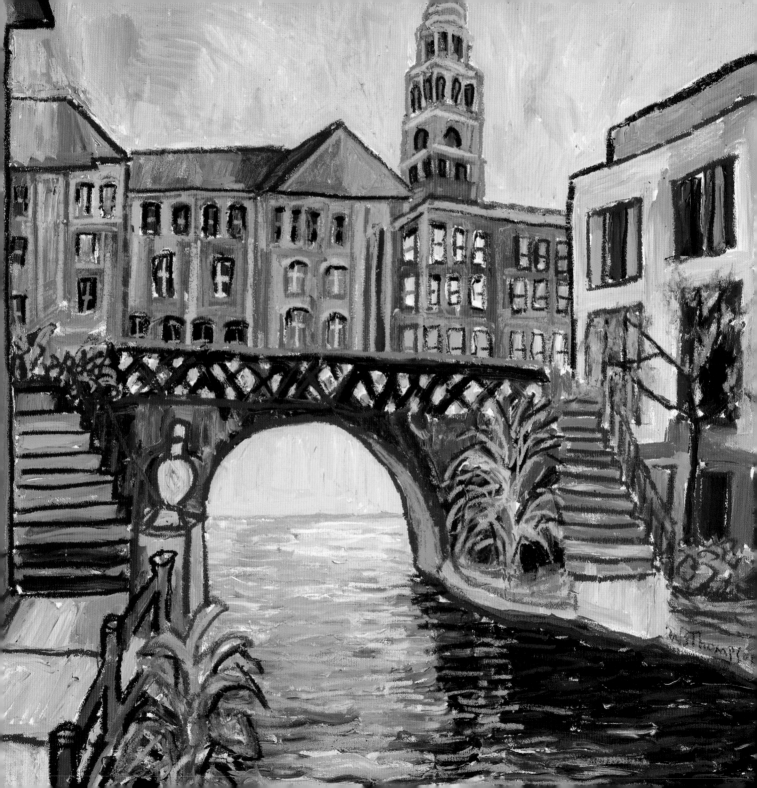

SOUTH RIVER WALK

San Antonio is every Texan's favorite town after his hometown.

Red McCombs

Olmos, San Pedro, Salado, and San Antonio—and the meandering acequias from which they drew their water for drinking, washing, irrigating, and milling. . . . In some magic way, by spending time in San Antonio you join your life forever to those historic streams, and among their winding valleys your fond memories will be buried deep.

Frank W. Jennings

WATERFALL, SOUTH RIVER

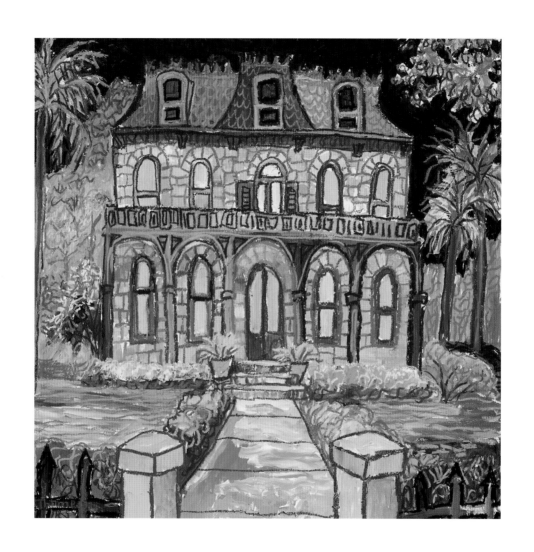

STEVES HOMESTEAD

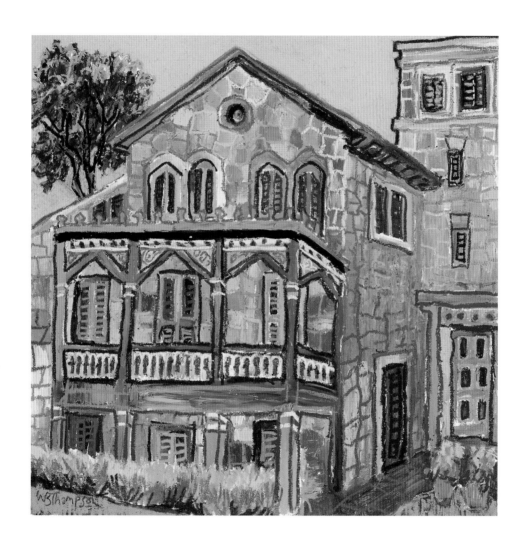

WULFF HOUSE

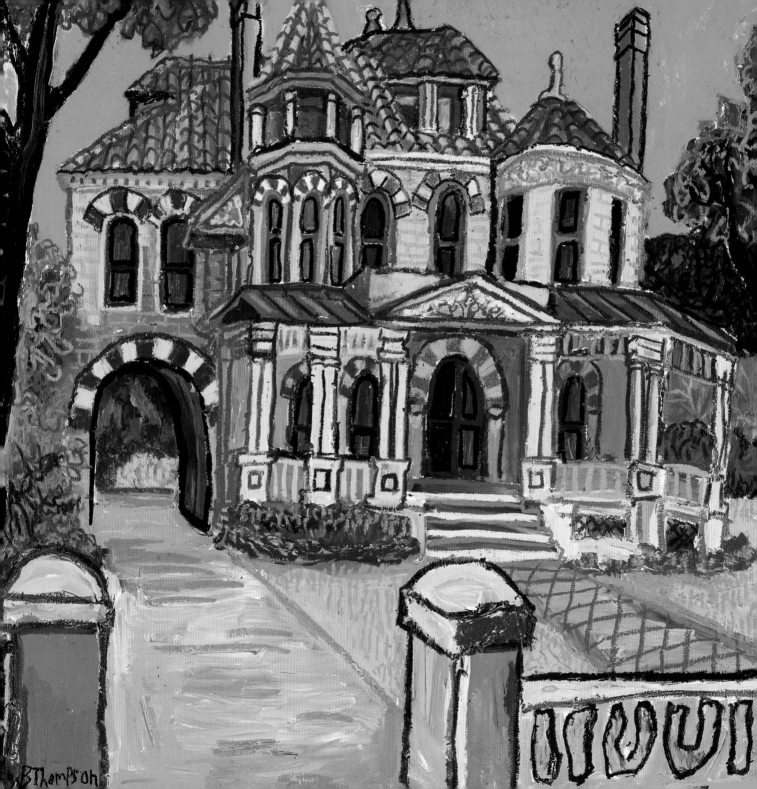

Radiating from the center of
the city . . . are residence streets
whose sidewalks are canopied
by tall, spreading trees. A flower
garden reaches from the steps
of the house to the street walk.

San Antonio Express, *August 31, 1897*

KING WILLIAM RESIDENCE

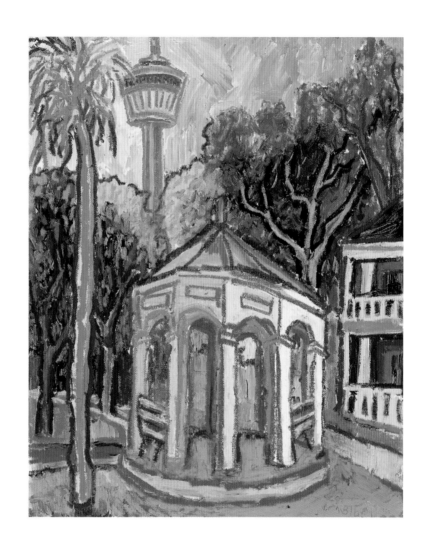

KING WILLIAM GAZEBO

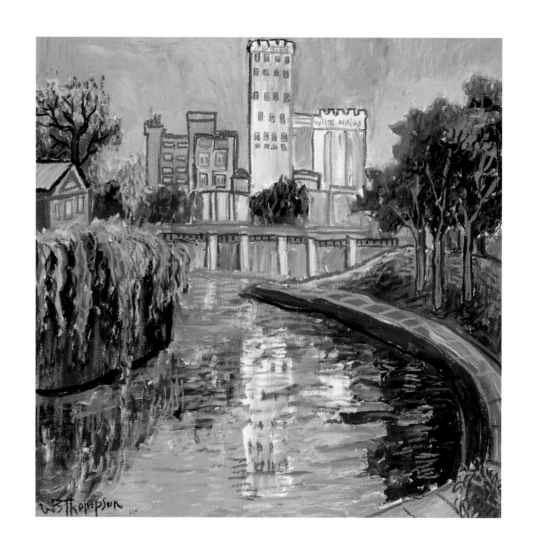

PIONEER FLOUR MILLS

152

The San Antonio Spring may be classed as of the first water among the gems of the natural world. The whole river gushes up in one sparkling burst from the earth. It has all the beautiful accompaniments of a smaller spring, moss, pebbles, seclusion, sparkling sunbeams, and dense overhanging luxuriant foliage. The effect is overpowering.

Frederick Law Olmsted

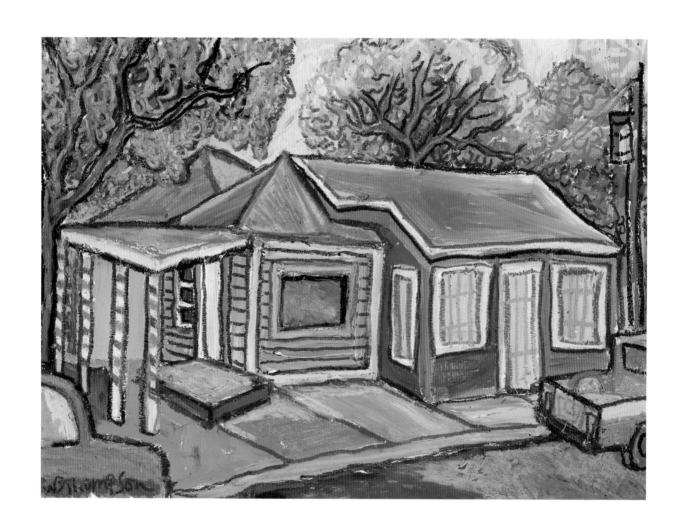

BARBER AND BARBECUE

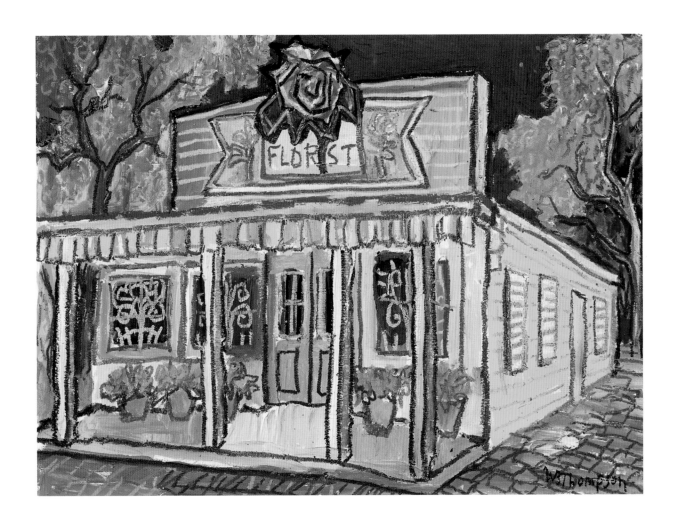

FLORIST

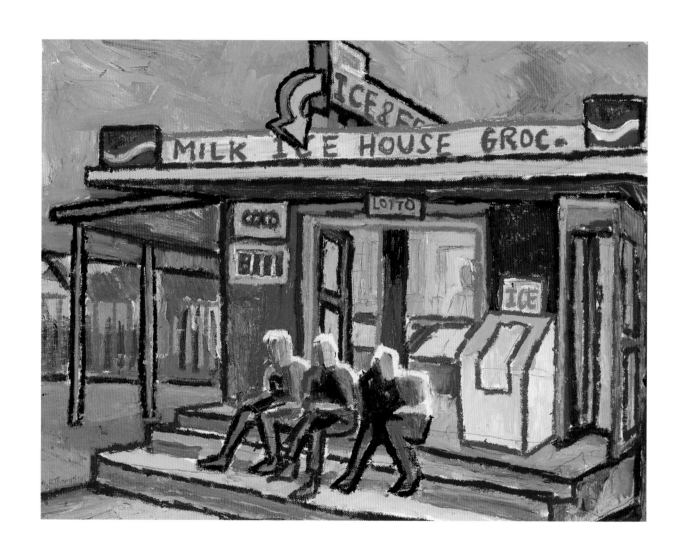

ICE HOUSE

In certain neighborhoods
the air is paved with names.
Domingo, Monico, Francisco,
shining rivulets of sound.

Naomi Shihab Nye

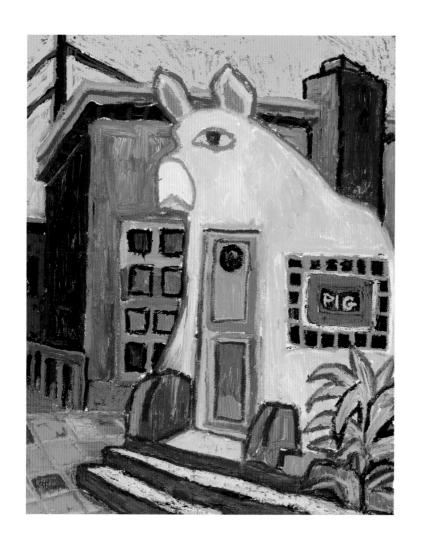

PIG STAND

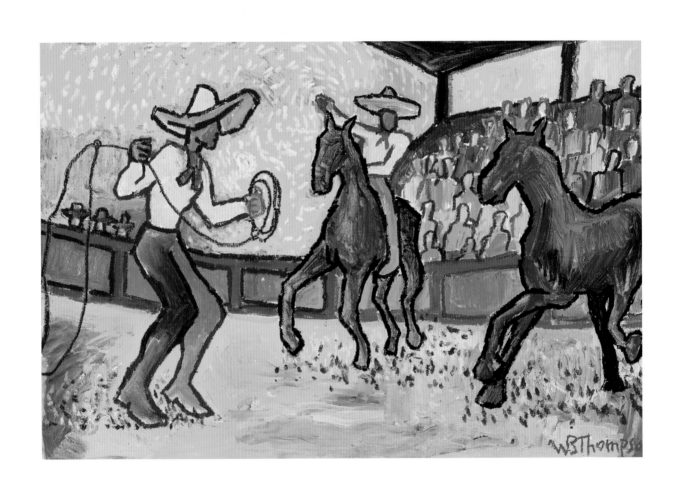

LA CHARREADA

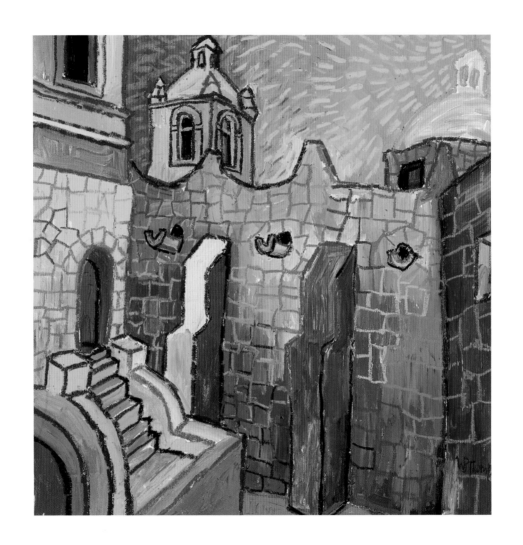

MISSION CONCEPCIÓN

About two miles lower down the San Antonio river is the mission of Concepción. It is a very large stone building, with a fine cupola, and though a plain building, is magnificent in its proportions and the durability of its construction.

Capt. Frederick Marryat

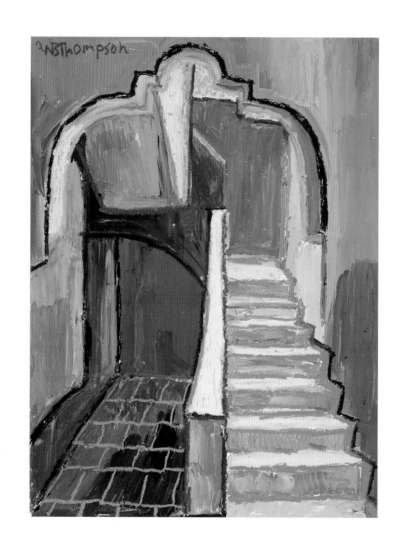

MISSION STAIRWELL

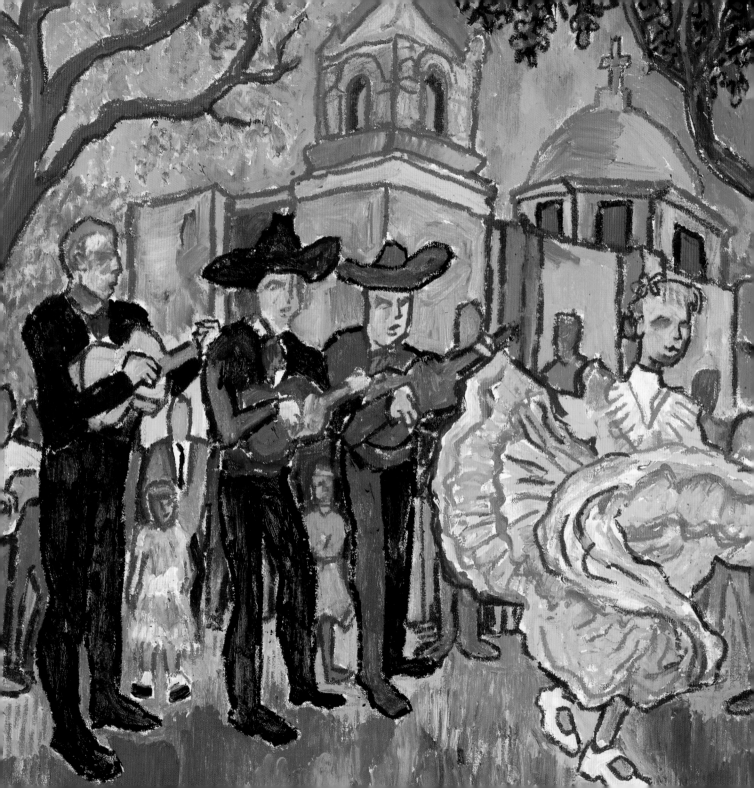

We have never really captured San
Antonio, we Texans — somehow
the Spanish have managed to hold
it. We have attacked with freeways
and motels, shopping centers, and
now that H-bomb of boosterism,
HemisFair; but happily the victory
still eludes us. San Antonio has
kept an ambience that all the rest of
our cities lack.

Larry McMurtry

MARIACHI MASS

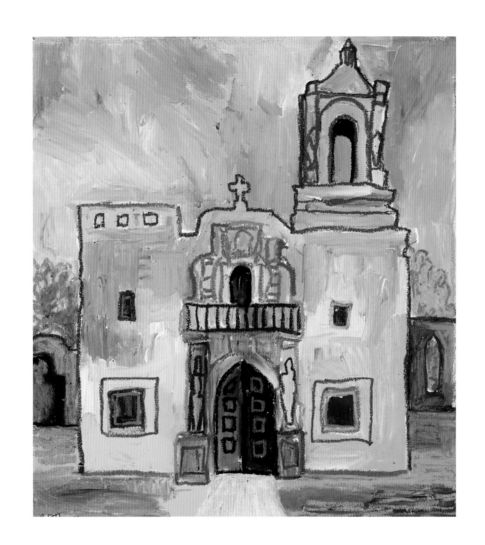

MISSION SAN JOSÉ

The mission of San José . . .
consists, like the others, of a large
square, and numerous Mexican
families still reside there. . . . The
west door is decorated with the
most elaborated carvings of flowers,
images of angels, and figures of the
apostles: the interior is plain.

Capt. Frederick Marryat

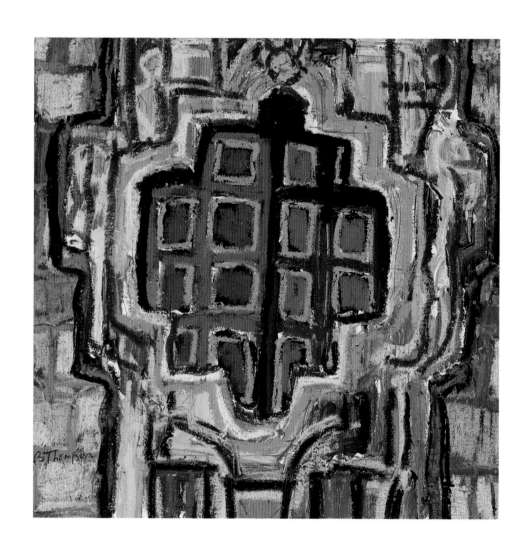

ROSE WINDOW

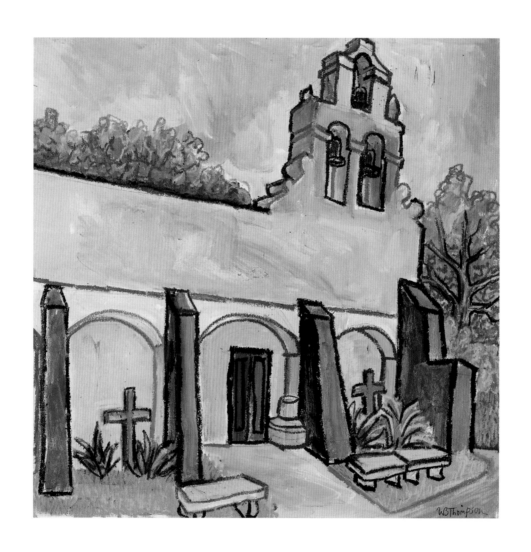

SAN JUAN CAPISTRANO

172

On cliffsides in the woods around San Antonio, there are petroglyphs where the Indians recorded their first impressions of the missions, los padres, and the Spanish vaqueros on their horses. Drawn in thick lines with dark vegetable inks on stone, churches appear as little arched sanctuaries, crowned by a cross. A stick figure is recognizable as a priest by an exaggerated mitred hat, just as the vaquero can be distinguished by his cocked sombrero.

John Phillip Santos

The Espada Aqueduct [is] the only surviving Spanish aqueduct in the United States. Water still flows, albeit sluggishly, along the gentle curve of the arched structure just as it did in the 1730s. . . . I was standing among the leavings of a European culture, scarcely modified by the exigencies of the New World.

Stephen Brook

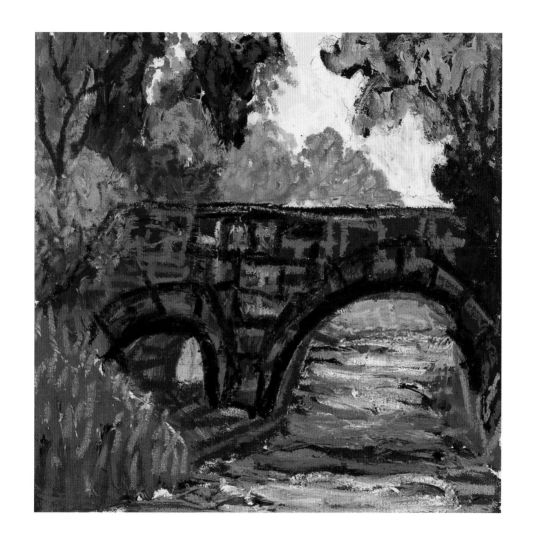

ESPADA AQUEDUCT

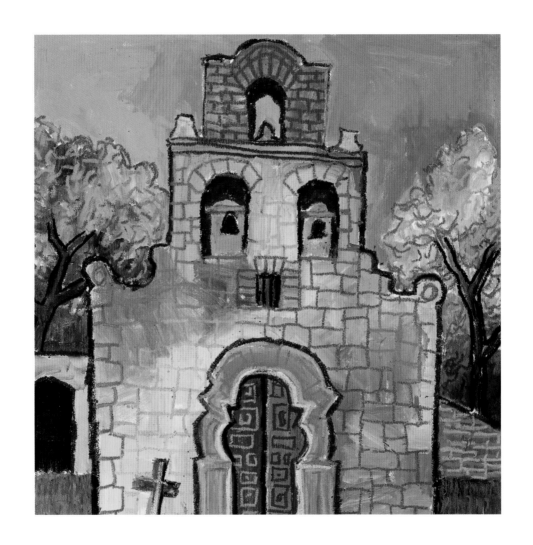

MISSION ESPADA

If it hadn't been for the river, the Yanaguana, the Rio San Antonio, thickly lined for miles with palmettos and yuccas, willows, oak, and huisache, there would have been no missions; and if there had not been missions, there might never have been a city.

John Phillip Santos

SAN ANTONIO HIGHLIGHTS

by Jenny Browne

SOUTH SIDE RIVER WALK PASSAGE *p. 10*

When journalist Ernie Pyle called San Antonio's River Walk development the "Venice of America" sometime in the 1940s, he was talking about the romantic mood of the area's winding flow of water and walkers. Indeed, the river is responsible for San Antonio's very existence. When the first group of Spanish settlers needed a camp for their expedition some 300 years ago, they picked a spot midway between the settled parts of northern Mexico and the French-controlled towns of East Texas. But they were not the first to note the river's beauty and utility. Coahuiltecan, Payay, and other native peoples already enjoyed this fertile river valley—a land they called "Yanaguana." The modern-day contrast of moods between the bustling streets above and the shady calm below is still largely responsible for San Antonio's beguiling ambience.

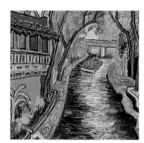

OLD CHINESE RESTAURANT *p. 14*

Though it's commonly called the "Old Chinese Restaurant," the building with the ornate Asian-influenced balcony overlooking the river near Houston Street never actually housed such a business. The balcony, built in 1910 as a feature of the Riverside Café by owner George Maverick, is part of the oldest surviving building on the Maverick Block to take advantage of its riverside location. Known as the "Father of Houston Street," Maverick worked tirelessly for the block's preservation. A soldier turned lawyer, real estate developer, and businessman, he built the headquarters for the U.S. Army on Houston Street in 1897. That building was later remodeled into the Maverick Hotel and then the Maverick Building. In 2000, the balcony was removed during construction of the Hotel Valencia. The thirty-six-foot-long, six-foot-deep, ten-ton balcony was reinstalled in 2002.

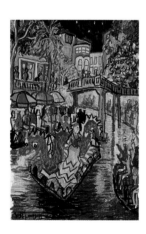

FIESTA NIGHT RIVER PARADE *p. 17*

On the first Monday of Fiesta week, elaborately decorated floats gracefully navigate the river and turn the night into a glowing spectacle. Staged annually by the Texas Cavaliers, the River Parade features the crowning of not one but two kings—King Antonio, in honor of the city's patron saint, Anthony of Padua, and El Rey Feo, or the Ugly King, who is selected by the League of United Latin American Citizens. Chairs a dozen deep line the banks of the river for this favorite Fiesta event.

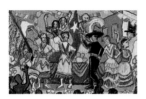

FIESTA PARADE FLOAT WITH DANCERS *p. 18*

In April 1891, women from the San Antonio Club decided to organize a parade to honor the heroes of the Alamo and the battle of San Jacinto, in which Texas won its independence from Mexico in 1836. The parade was scheduled for April 21, San Jacinto Day, but was changed to April 20 when the women learned that President Benjamin Harrison would be visiting the city. The Battle of Flowers theme was inspired by the flower carnivals of France and Mexico and the parades of Germany. Although it rained that day, and although the president had long left town when the parade started four days later, the event was a success. At the signaled time, participants wheeled around Alamo Plaza in opposite directions, showering each other and spectators with flowers. Still the focal point of the ten-day Fiesta celebration each April, the Battle of Flowers Parade draws some 300,000 spectators.

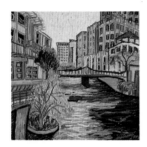

VIEW TO PRESA BRIDGE *p. 21*

During the transformation of the sleepy San Antonio River to the bustling River Walk, the Presa Street bridge was too low to have a walking path constructed beneath it, so engineers built a walkway that curved into the river and appeared to float. Looking up from the walkway, one can see the radical reconstruction of the Main Library into San Antonio's International Center. The building, built in the late 1960s, was vacated when the Central Library opened in 1995. Acclaimed local architecture firm Lake/Flato transformed the building into a modern stucco and steel structure with quartets of massive windows and balconies projecting over the river.

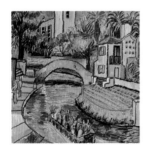

ARNESON RIVER THEATER *p. 22*

For twenty-six years Rosita Fernández walked across an arched bridge to stage right of the Arneson River Theater, where she starred in the Alamo Kiwanis Club's Fiesta Noche del Rio. Known as "San Antonio's First Lady of Song," Fernández was such a favorite that when she retired, the bridge was officially named Rosita's Bridge. One of the few artists in Texas-Mexican music to be cast in feature films, Fernández appeared in *The Alamo* with John Wayne. The charming outdoor amphitheater, with its stone archways and tile-roofed dressing rooms, was originally called the Broadcast Theater but was later renamed for WPA engineer Edwin Arneson. In addition to Fernández's performances, the site has hosted everything from Western radio dramas and mariachi competitions to operas and the *Bam!* antics of celebrity chef Emeril Lagasse.

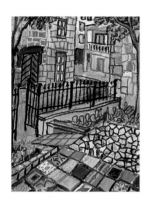

LA VILLITA MOSAIC *p. 25*

La villita, Spanish for "little town," is the name of one of San Antonio's first residential settlements. Located on one square block in the heart of downtown, just three blocks south of the Alamo, the area is home to restaurants and shops showcasing the works of artists and craftspeople. Amid beautifully landscaped grounds, historic buildings range from simple adobe to early Victorian and natural-cut limestone structures.

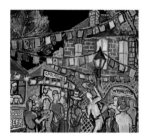

CASCARÓN BAPTISM *p. 26*

Here they come. They have their hands tucked suspiciously behind their backs and a manic gleam in their eye. You know you should be wary, but for an instant you forget why. The distinctive crunch of a *cascarón* on the top of your head reminds you. Confetti tumbles to your shoulders. You'll pick the pieces from your hair for the rest of the day. Your laughing attackers scamper off to reload and find another victim. Many San Antonians save eggshells year-round to make *cascarones.* The hollowed-out shells are filled with confetti and sealed across the top with brightly colored tissue paper. Most commonly found during the city's annual weeklong Fiesta celebration, cascarones are also part of festivities ranging from birthdays to baptisms.

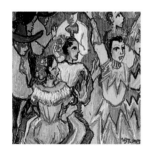

FESTIVAL DANCERS *p. 28*

Amid the flashing colors, dancing, and music, the history of a culture unfolds with the precise movements of a ballet folklórico troupe. The elaborate rainbow-hued costumes include hair combs and fans from Spain, traditionally used in flamenco. The dancers' steps reflect the Aztec and Mayan cultures from which the dances evolved.

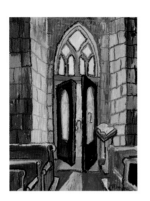

LITTLE CHURCH OF LA VILLITA *p. 31*

Rev. John Wesley DeVilbiss, a Methodist circuit-riding preacher, galloped into San Antonio in 1844. His first pulpit was a plot of land he purchased on the San Antonio River, at the corner of Villita Street and Womble Alley, near what is now the Arneson River Theater. A rack was built with a bell that called people to worship. Spanish parishioners took to calling DeVilbiss *el padrecito que tiene la compana,* or "the little father with the bell." DeVilbiss did not have enough money to build a church on the site and eventually continued his nomadic ways, but in 1879 the Little Church of La Villita, a Gothic Revival building, was built of stone blocks from the quarry in Brackenridge Park. Inside are hand-hewn pews, an old pump organ, and stained-glass windows that open on the original wooden pegs. Built by the German Methodists, the church today holds nondenominational services.

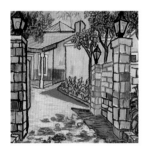

GATE TO LA VILLITA *p. 32*

East of Main Plaza and south of the bend in the San Antonio River, a stone gate provides entry to La Villita, a pastoral world amid the downtown bustle. In late September, visitors are treated to the sounds of the International Accordion Festival. An instrument brought to Mexican Tejano music by German rail workers, the accordion is the perfect background music for this, one of the city's first settlements, dating to the days when San Antonio was equal parts German, Mexican, and English-speaking. Small European-style cottages interspersed with Mexican *jacales* and adobes housed the hardworking people of nineteenth-century San Antonio.

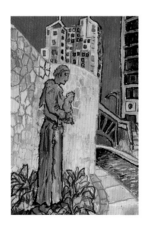

ST. ANTHONY STATUE *p. 34*

St. Anthony of Padua was a thirteenth-century Franciscan famous throughout Italy for winning converts with his fiery preaching. He became San Antonio's namesake when Father Damien Massanet celebrated the first mass on the banks of the San Antonio River on June 13, 1691, the feast day of St. Anthony, during a Spanish expedition led by Domingo Terán de los Ríos. But St. Anthony of Padua was not Italian. Born in Portugal, he is that country's patron saint. The bronze statue on the River Walk near Rivercenter Mall was presented to the city during HemisFair '68. His open arms are surrounded by outstretched palm fronds. Fragrant ginger, jasmine, and brugmansia sweeten the air as brilliant bougainvilleas trumpet a fuchsia song.

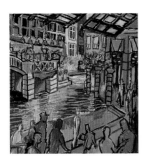

RIVERCENTER MALL *p. 37*

"Just add water" was the slogan for the $200 million, ten-acre, one-million-square-foot Rivercenter Mall when it opened in 1988 on a new branch of the HemisFair river extension. One hundred thirty-five shops and restaurants and a state-of-the-art Imax theater surrounded the new lagoon. Today, dramatic performances are held on an island platform in the middle of the lagoon, and visitors who seek a little quiet can eat their ice cream cones next to the San Antonio de Padua statue.

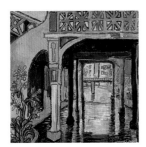

UNDER COMMERCE STREET *p. 38*

Commerce Street has been San Antonio's principal downtown thoroughfare almost since the city's beginning. A symbolic link between the primarily Hispanic west side and historically African American east side, the street was also an early commercial hub. In fact, the city's first streetcars were permitted to run anywhere but here so as not to disturb business. Twenty feet below Commerce Street's constant traffic of city buses, teenage cruisers, and tourists is a cypress-lined walkway where you can follow your nose to Casa Rio, the Mexican restaurant that opened in 1946 as the River Walk's first business. Before descending, though, take a moment to pause on the bridge and recall that pedestrians first crossed the river here in the 1730s. Early bridges floated a foot above the water on wooden barrels. They were chained to trees on either side; during rising waters, chains on one side were released so that the bridges could be swept to the other side. In the early twentieth century, iron bridges, made by the Berlin Iron Bridge Company of East Berlin, Connecticut, became distinctive municipal ornaments. The most ornate graced 1800 Commerce Street and featured tall iron spires. Even then, the bridge reflected San Antonio's cultural diversity with its sign warning riders in three languages—German, Irish, and Spanish—that horses must be walked. A wider bridge of concrete eventually replaced the iron one. With help from Italian-born sculptor Pompeo Coppini, the bridge incorporated street-level alcoves and concrete ornamentation still visible from the riverbanks.

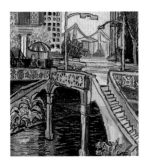

RASPA CART *p. 41*

On a hot summer day, the striped umbrella shading a downtown street corner is a San Antonio oasis that draws thirsty pilgrims of all ages for one thing—*raspas*. Whether sprinkled with chili powder, laced with coconut, or steeped in sweet fruit syrups, a raspa quenches the thirst. Peddled from curbside stands and carts, the shaved ice concoction, sometimes called a snowball, comes in flavors ranging from bubble gum to pickle to tamarind. Cherry too boring? Try mango. Need something with bite? The *diablito*, or little devil, with lemon and chili is pure pucker pleasure and is also rumored to cure hangovers. Can't decide? At a dollar apiece, get two—or mix flavors to make a raspa ritual of your own.

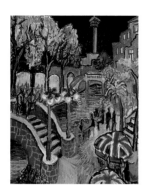

KANGAROO COURT *p. 45*

One of the oldest restaurants on the River Walk, the Kangaroo Court below the Casino Building block was known for both its cheesecake and its highly educated, if somewhat surly, wait staff. Indeed, the lively Court often lived up to its name as a place where much of the action happened behind the scenes. As one former waiter put it, "We were like that place whose whole gimmick is to train waiters to be mean to customers, only we didn't need training." Nevertheless, the popular River Walk watering hole drew a mixed clientele of locals and tourists until it closed in 2002.

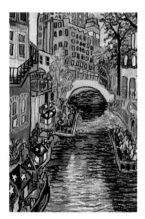

CASINO BUILDING *p. 46*

Constructed in 1926 as the home of the Casino Club, a German social club, and the San Antonio Club, a club for well-educated Anglo elites, the Casino Building was known as the San Antonio-Casino Club until 1933. Thomas Gilcrease, owner of the Gilcrease Oil Company, purchased the building in 1942, and his office and collection of Western art occupied the space until 1952, when it was sold to C. B. Erwin and the General American Casualty Company. The site gradually declined and housed numerous short-lived ventures until its purchase by the Casino Club Ltd. in 1978. Now home to apartments and street-level shopping, the unique six-story building was designed to fit a roughly triangular site bounded by two streets and the San Antonio River.

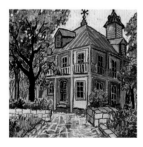

SOUTHWEST SCHOOL OF ART & CRAFT *p. 49*

According to Paula Owen, director of the Southwest School of Art & Craft, "to be profound, art must move you in some direction, and for whatever reason this place moves you. Perhaps it is the architectural details, perhaps the intimate spaces. Maybe it is the sense of how technical and material come together." Owen describes the school's work as creating opportunities for direct experience with art both through creation and viewing. The limestone buildings of the school's Ursuline Campus, which opened in 1971, are part of the former Ursuline Academy and Convent. Founded by French Ursuline nuns in 1851, the all-girls school and convent featured a beautiful chapel with stained-glass windows imported from France and expansive courtyards. Today the school offers courses in ceramics, sculpture, painting, photography, and other arts and crafts, and its appealing historic campus includes a restaurant, a gift shop and visitors center, and a gallery.

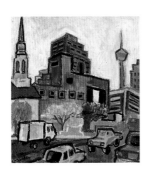

CENTRAL LIBRARY *p. 50*

San Antonio's biggest red enchilada isn't found on a dinner plate at any of the city's ubiquitous Mexican restaurants. It's a six-story building with cascading purple spheres, angular atriums, open-air patios, leather couches, and stunning views of downtown. Dubbed the "Big Enchilada" for its distinctive color, the Central Library was designed by Mexican architect Ricardo Legoretta. In addition to turning heads, the library turns on minds with its collection of books, videotapes, audiotapes, CDs, DVDs, books on tape, a great children's area, youth-wired services, a one-stop Texas genealogy center, and a burgeoning Latino collection. A contest hosted by the *San Antonio Express-News* to name the building's color drew nearly a thousand entries. In the end, twenty-one people suggested "enchilada red." Other suggestions included Dewey Decimal Red, Liberry Red, San Antonio Rose, Rusty Chevy, Red All About It, Prose Red, Literary Blaze, and Well Read Red.

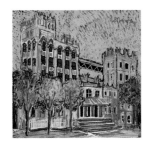

SAN ANTONIO MUSEUM OF ART *p. 51*

In 1972, San Antonio Museum of Art officials began looking at the old Lone Star Brewery on Jones Street as a possible site for an art museum that would be spun off from the Witte Museum. The nine brewery structures had been built between 1900 and 1910, and their modified Italian Romanesque buildings, with thick supporting walls, cast-iron supports, floors of reinforced concrete, and two towers connected by an iron catwalk, were an exciting choice. In July 1977, then-Mayor Lila Cockrell opened the building with a bottle of bubbly. It seemed fitting for a place that had housed the works of St. Louis beer tycoon Adolphus Busch since 1903. The large areas that once held fermentation cauldrons now hold works of art. One of the museum's focuses is the extensive collection in the Nelson A. Rockefeller Center, the nation's first center for Latin American art.

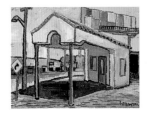

NORTH ST. MARY'S STREET GAS STATION *p. 52*

Just before the bend that leads to the nightclubs, restaurants, and shops that people call the North St. Mary's Street strip, an old gas station leans into its shadow. It's just one of many details on a changing street that follows the stagecoach trails from the missions through downtown. This station has known the sound of horses, cars, and now a few moments of quiet memory.

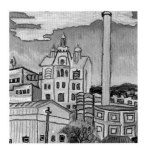

PEARL BREWERY *p. 55*

It's been called the brewery with nine lives. Indeed, the Pearl Brewery—"pearl" being an English translation of the German term used to describe the bubbles in lager beer—got its start in 1886, a year after German immigrant Otto Koehler and three business partners bought a failing brewery and renamed it the San Antonio Brewing Association. Under Koehler's leadership, the business expanded quickly, constructing many of the historic buildings still in use at the seventeen-acre compound. By 1916 it had grown into the state's largest brewery. Prohibition, however, forced the company to halt its brewing operations, produce ice and dairy products, and diversify into dry cleaning and auto painting to supplement earnings. On September 15, 1933, the day Prohibition ended, the brewing line was back in operation. The firm, eventually renamed the Pearl Brewing Co., stayed in the Koehler family while sales skyrocketed during the 1950s and early 1960s. For sixteen straight years, Pearl was Texas's best-selling beer, before the company's fortunes began to change. The brewery closed in 2001.

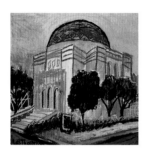

TEMPLE BETH-EL *p. 56*
Located just north of downtown at the corner of Belknap and Ashby, Temple Beth-El is a reform Jewish synagogue serving approximately 1,250 families. Organized in 1874, the original temple stood at the corner of Travis and Jefferson Streets. Following the temple's dedication, the *San Antonio Daily Express* gave a detailed description of the event: "The beautiful building was soon filled to the utmost capacity. The congregation present was composed indiscriminately of Jews and Christians. Protestants and Catholics and all joined reverently and devoutly in the solemn and impressive religious services of the hour." A new building was built in 1903 on the same site to accommodate the growing congregation, but by 1913 membership was listed at 145 more than the building could reasonably hold. The current temple was completed in 1927 with a sanctuary that can seat up to 1,600.

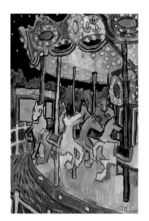

BRACKENRIDGE PARK CAROUSEL *p. 58*
What could be controversial about a carousel? You pick your pony, pay your penny, and ride in slow circles. Yet lines were drawn deep in the sand during the construction of the Brackenridge Park carousel. First opposed by heirs to nearby Koehler Park, the carousel sought an alternate site at Brackenridge Park. Additional opponents, including the San Antonio Conservation Society, argued that amusement rides violated the intent of George Brackenridge, who had donated the land to the city to be used as a woodsy retreat near the source of the San Antonio River. With an eye firmly on the $100,000-a-year lease agreement, the city made a compromise and the parking lot outside the entrance to the zoo was reconfigured to accommodate the ride. Installed in 1988 and now closed, the sixty-horse fiberglass carousel had some 2,000 lightbulbs. In a front-page photo the day the ride opened, a three-year-old boy, oblivious to the controversy, squealed open-mouthed from his circling mount.

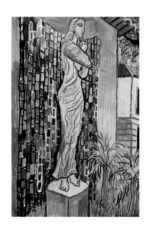

WITTE SCULPTURE *Mother and Child* *p. 59*
Upon completion of the Witte Museum's facade in 1960, the museum association called on Texas artists to submit designs for sculpture to grace the front of the museum. The winning artist, Charles Umlauf, was a well-known sculptor who taught in the fine arts department at the University of Texas at Austin. His piece, Mother and Child, was funded by museum trustee Joan Brown Winter, in memory of her son Philip, who died in infancy. Umlauf also completed a companion piece, *Father and Child*, in 1962.

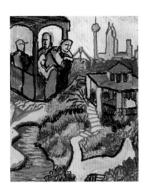

JAPANESE TEA GARDEN *p. 61*

In 1915, Parks and Sanitation Commissioner Ray Lambert, namesake of Fort Lambert Beach in Brackenridge Park, commissioned Japanese artist K. E. Jingu to design a garden in the rock quarry that had supplied limestone for many San Antonio structures and for the state capitol in Austin. Jingu designed a Japanese tea garden that was then built by prison laborers. Jingu and his family lived in San Antonio and operated the tearoom at the Japanese Tea Garden until 1938. Fortunately, they did not live to witness the harsh reaction to people of Japanese descent during World War Two. During the war, Jingu's family was forced to return to Japan and the tea garden was renamed the Chinese Tea Garden. In 1985, the original name was reinstated. A cool spot in spring and summer, the gardens overflow with hundreds of varieties of plants along the path, which winds past ponds and fountains. The kiln and houses for quarry workers can still be seen.

GARBAGE CAN AT KIDDIE PARK *p. 62*

On this day the roller coaster is broken. The foot on a carousel horse is missing, and the boat ride looks like it has been too long at sea. But there is still a line, and there is still laughter. A grandfather takes the hand of his grandson, just as his grandfather did when Austinite P. W. Curry opened Kiddie Park in 1925. Back then, goats and ponies pulled the rides. Today nostalgia and history keep everything going. Bob Aston bought the park from Curry in 1978 in part because it was the place where he celebrated his own fifth birthday. And if a few of the rides feel like they've been around forever, that's because they have. The merry-go-round was built in 1918 and brought to Kiddie Park from Miami in 1935. The airplane ride dates to the 1940s, the boat ride to the 1950s; the "newest" ride—the helicopter/flying saucer—arrived in 1962. Kiddie Park is one of a handful of amusement parks nationally to prevail in the face of high-tech competition. Only three parks in the country are older, and they weren't established to cater to kids. Still billed as America's oldest original children's amusement park, this aging one-acre piece of Americana on Broadway keeps going strong.

SAN ANTONIO BOTANICAL GARDEN *p. 65*

The Sullivan Carriage House at the San Antonio Botanical Garden was built in 1896 by architect Alfred Giles for one of the most colorful figures of early Texas, Daniel J. Sullivan. An Irish immigrant, Sullivan served in the Texas Cavalry during the Civil War. In 1882, he founded D. Sullivan & Co. Private Bankers, whose loans made possible the legendary cattle drives of the nineteenth century. Giles was commissioned to design the coach house and stables, to be built behind Sullivan's home at Fourth Street and Broadway, and produced this superb example of the round-arched Richardsonian Romanesque style. In 1987, the San Antonio Botanical Society was offered the carriage house with one caveat: it must be moved within three months. Through a major grant from the San Antonio Conservation Society, the building was disassembled, moved stone by stone, and reassembled at its present site. In 1995, after several years of careful restoration, the Daniel J. Sullivan Carriage House was given new life as the entry to the San Antonio Botanical Garden. Visitors pass through the house to explore a wide range of gardens. There are older flower varieties in the old-fashioned garden, sensory pleasures in the Garden for the Blind, Japanese-inspired plants in the Kumamoto En garden, drought-tolerant plants for South Texas in the Watersaver Garden, and a place to sit and ponder the blooming beauty in the Sacred Garden.

TRINITY CHAPEL *p. 67*

The striking Margarite B. Parker Chapel at Trinity University features stained-glass windows, tall vaulted walls, and meditation gardens. Behind the pulpit, a 109-rank pipe organ dominates the wall. Nondenominational services presided over by the university chaplain are held every Sunday. Though affiliated with the Presbyterian Church, Trinity has student organizations of different denominations, including the Jewish Student Association, Muslim Student Organization, Baptist Student Union, Catholic Student Group, Asian Christian Fellowship, Navigators, and InterVarsity Christian Fellowship. One of many campus buildings designed by O'Neil Ford, the chapel crystallizes Ford's "hill-town motif" vision for the school.

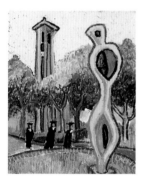

TRINITY TOWER *Large Interior Form* *p. 68*

Of the forty-six buildings O'Neil Ford designed for Trinity University, four are notable for their structural and architectural sophistication. They include the Margarite B. Parker Chapel, the Ruth Taylor Theater, Laurie Auditorium, and—literally towering above all—the T. Frank Murchison Tower. The 166-foot-high bell tower uses technology that dates back to ancient Rome. Instead of pouring a concrete shaft and facing it with brick, Ford had masons lay the brick perimeter walls and pour concrete between them. A series of vertical Vierendeel trusses provides the interior bracing. Situated on an esplanade overlooking the San Antonio skyline, the site provides a spectacular view of both the city and the attractive lower campus. Another Trinity landmark, Henry Moore's 1981 *Large Interior Form*, sits nearby.

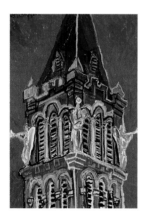

MOTHERHOUSE, UNIVERSITY OF THE INCARNATE WORD *p. 71*

The teaching and missionary order of the Sisters of Charity of the Incarnate Word, founded in France in the 1860s, arrived in Texas in 1869. They opened Santa Rosa Hospital the same year. In 1897, the sisters reportedly paid $100,000 to George Brackenridge for his 283-acre estate, known as Head-of-the-River. Eventually they outgrew the villa on the estate, and in 1900 they moved into the newly completed Motherhouse. Built by Alfred Giles, an English-born architect responsible for the historic Menger Hotel, the Steves Homestead, and many other San Antonio buildings, the four-story Motherhouse had exterior brick walls that were twenty inches thick and rested on a concrete foundation. Interior walls were ten to twelve inches thick. Giles's unique polychromatic contrast of lighter stone trim on red brick drew emphasis to the entry doors, windows, and details. The adjoining Motherhouse Chapel was designed by Fred Gaenslen and dedicated in 1907. Dominated by a tower adorned with four angels carved in white stone, the building features columns of scagliolia and gilded Romanesque capitals. It was renovated in the late 1980s when the sisters razed the original Motherhouse to make room for a new one. Stone, brick, doors, glass, and ornaments from the previous building were salvaged for use throughout the new facility.

CHILE PEPPERS, CENTRAL MARKET *p. 72*

Chile peppers, whether dried, pickled, or stewed, are one of San Antonio's favorite foods. In fact, in the nineteenth century the city was known throughout the country for its Chili Queens, who sold chili con carne from their stands at Military Plaza. San Antonio Commissioner Frank Bushick said in 1927, "Every class of people in every station of life patronized [the chili vendors] in the old days. Some were attracted by the novelty of it, some by the cheapness. A big plate of chili and beans, with a tortilla on the side, cost a dime. A Mexican bootblack and a slick-hatted tourist would line up and eat side by side, either unconscious or oblivious of the other." Chiles still abound throughout the Alamo City, from Market Square to H-E-B's Central Market on Broadway.

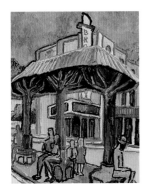

ALAMO HEIGHTS BUS STOP *p. 74*

In the early 1900s, Alamo Cement Company employees who relied on public transportation disembarked at this trolley stop on Broadway at Patterson Avenue and walked three miles to the factory. Built by Dionicio Rodríguez and Maximo Cortés, the stop is one of several "faux wood" structures made of delicately carved concrete. While Rodríguez was secretive about his technique, Cortés's son Carlos absorbed enough to carry on the traditional art form in his Southtown studio. Other sculptures by Rodríguez and Cortés can be seen in Brackenridge Park and at the entrance to the Japanese Tea Garden.

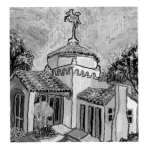

OLD GAS STATION *p. 75*

The glowing red Pegasus has prepared for flight above the historic Mobil station at the intersection of Broadway and Austin Highway since 1911. The horse is now property of the San Antonio Conservation Society, which oversaw Glen Huddleston's renovation of the building in the late 1980s. First renovated in 1936, the building features Spanish wrought iron and Mexican decorative tile. Over the years it has housed Rhonda's Interior Design and the popular Harold's Clothing before becoming home to River & Ranch Outfitters.

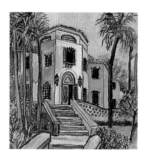

McNAY ART MUSEUM *p. 76*

The McNay Art Museum sits atop a hill in northeast San Antonio surrounded by twenty-five rolling acres of landscaped gardens, sculptures, and fountains. Marion Koogler McNay bequeathed the Spanish Colonial Revival–style mansion, constructed in 1929, and her extensive art collection, which focused on first-generation postimpressionist and American watercolorists, to the museum association. Always interested in art, McNay studied at the University of Kansas and the Art Institute of Chicago. After the death of her parents, she inherited the family's oil fortune, and in 1926 she moved to San Antonio after marrying a San Antonio physician. She soon began construction on the mansion on an acreage called Sunset Hills, at the intersection of Austin Highway and New Braunfels Avenue. The museum, which opened in her residence in 1954, was the first museum of modern art in Texas. The grounds alone are worth a visit and include a Japanese garden, fishpond, and lush, broad lawns that are often dotted with tuxedoed men and gowned women posing for wedding photos.

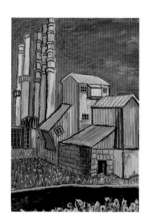

ALAMO CEMENT COMPANY *p. 78*

Many a visitor has driven into the city from the airport, heading south on Highway 281. Along the way, a line of towering smokestacks rises to the east. These stacks are now architectural details of the Quarry Market shopping center, but they weren't always mere decoration. The shopping center is located on the former grounds of the Alamo Cement Company. The surrounding area, known as Cementville, was once home to hundreds of the company's workers and their families. Chartered in 1880 when Englishman William Loy discovered natural cement rock near San Antonio, the company's first plant was powered by steam and produced ten barrels of cement a day. In 1908 the company founded Cementville, which eventually included housing, a swimming pool, a recreational hall, and a school. Nearby Alamo Heights became an independent municipality in 1922, and with completion of the Olmos Dam grew into one of the city's wealthiest communities, surrounding Cementville. In 1949, though, workers could still rent a home for $3 a week, and the communities remained largely separate. Alamo Cement built a modern plant outside Loop 1604 in 1980, and Cementville closed, falling into disrepair. In the 1990s, the area was developed into Lincoln Heights, a residential community, and the former plant was turned into retail space, restaurants, and a movie theater. These days, little remains of the industry that once thrived on this spot. A mock display of the cement factory, complete with lights and sound effects, occurs regularly inside the movie lobby. The machine is fake, but the photographs that line the walls are authentic.

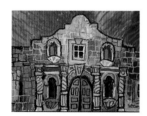

ALAMO *p. 80*

Best known as the site of the bloody battle between Mexicans and Texas settlers, the Alamo began its existence as San Antonio de Valero, the first Spanish mission in the San Antonio River valley. Founded in 1718, the Alamo was constructed in its present location six years later. In 1719, Father Antonio Olivares, the mission's first priest, moved it just east of the river bend, about where Saint Joseph's Church stands today. But in 1724, a hurricane destroyed the huts and a small stone tower at the second location, and Mission San Antonio de Valero was moved to its final resting place a bit to the north. According to San Antonio writer Jan Jarboe Russell, "If Texas were a religion, not just a state, then the Alamo would be the holy of holies. Even though the Texans lost the battle of the Alamo, they went on to win the land we call Texas a few weeks later at the Battle of San Jacinto. These days it means different things to different people. . . . It has become the embodiment of the great Texas myth, the idea of starting again—of striking it rich, if not this year then maybe next. To many, however, the Alamo is a symbol of conquest. The Texans were fighting for land that belonged to Mexico. It was a war over real estate, and ultimately the Mexicans lost. In a city with the largest percentage of Mexican Americans in the United States, it's easy to understand why the Alamo carries equal measures of guilt and heroism."

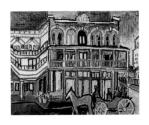

FAIRMOUNT HOTEL *p. 85*
The three-story Italianate Victorian Fairmount Hotel was built in 1906. It later attained Guinness Book of Records status as the world's heaviest mobile building, after its relocation from the corner of Bowie and Commerce Streets to a spot six blocks away on South Alamo Street. For four days in 1985, the city watched as the 3,200,000-pound building was moved on thirty-six dollies with pneumatic tires across the San Antonio River to its new location.

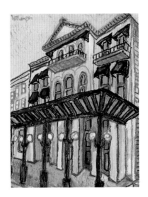

MENGER HOTEL *p. 86*
The Menger Hotel opened its doors on Alamo Plaza in 1859 to serve the commercial district growing up around the Army's Quartermaster Depot, located in the old Alamo. When celebrities, politicians, and businessmen came to San Antonio, the Menger was the place to stay. Its history includes such famous guests as Gen. Robert E. Lee, Richard King of the legendary King Ranch, poets Oscar Wilde and Sidney Lanier, writer O. Henry, and Teddy Roosevelt, who recruited his famous Rough Riders from the Menger Bar.

TWENTY FLOORS UP *p. 88*
Downtown, there are three ways to view the scenery: from the banks of the river, from the streets, or from a window twenty floors up, where the curving streets and the river cross like a braid and the Tower Life Building glows with the colors of Christmas, Fiesta, or the San Antonio Spurs, depending on the season.

FIESTA ROYALTY *p. 92*

Official or not, Fiesta royalty adds a majestic touch to an already grand celebration. From King Antonio and King Anchovy, to King and Queen Huevo, to the Queen of the Order of the Alamo and the Queen of the Royal Order of the Chupacabra, every crowned head has the same goal: to enjoy Fiesta. Virginia transplant John Baron Carrington founded the Order of the Alamo in 1909 and is credited with introducing the idea of Fiesta royalty. In 1926, the Texas Cavaliers, a men's organization, elected the first King Antonio from its ranks to reign alongside the Queen of the Order of the Alamo. More than twenty years later, in 1947, the League of United Latin American Citizens elected its own representatives, El Rey Feo, literally the Ugly King, and La Reina de la Feria de las Flores, or Queen of the Fair of the Flowers. The Queen of Soul and the Queen of the San Antonio Charro Association were added to the majestic list in 1969. Four years earlier, in 1965, the Woman's Club of San Antonio elected a Fiesta Teenage Queen, and Miss San Antonio was the last "official" royalty to join the regal ranks in 1978. The Fiesta San Antonio Commission two years later put a cap on the number of queens and kings who could officially participate in Fiesta. According to the bylaws that govern the commission, nine people are considered Fiesta royalty. But enter a string of unofficial officials, including but not limited to King Anchovy (est. 1951), the Fiesta Hat King (est. 1995), Miss Fiesta Senior Queen (est. 1998), and the King and Queen of the Royal Order of the Chupacabra (est. 1999), to lend the festivities a little less pomp and a little more imagination.

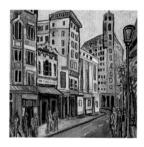

HOUSTON STREET *p. 95*

In one of his *San Antonio Express-News* columns, before his death in 2003, San Antonio civil rights lawyer and rabble-rouser Maury Maverick considered Houston Street's pending restoration. "We start our walk at the northwest corner of Houston and St. Mary's streets under the 100-year-plus heartwarming landmark, the Hertzberg clock. The ghost of Harry Hertzberg gives us a handshake . . . Senator Hertzberg says to us, 'This street was named after Sam Houston, who kept his treaties with the Indians, asked that African-Americans be treated fairly and stood with the German immigrants in their lonely day of the Civil War. Keep this a street for all people.'" Fellow columnist Paula Allen calls historic Houston Street "a cross between an Easter parade and a festival marketplace, especially on weekends. People dressed up to go downtown, whether for business, shopping or entertainment." Indeed, before the suburban flight of the 1960s, Houston Street had all three. But throughout the 1970s and 1980s, it became a tale of two cities—that of low-income residents who rode the bus in to shop the discount stores, and middle- and upper-income residents from the suburbs who staffed the high-rise buildings and searched the streets for good lunch spots. Still home to the Majestic Theater and the Gunter Hotel, where it is said bluesman Robert Johnson made some of his most famous recordings, Houston is a street full of stories. An urban development firm, working with preservationists, has spearheaded a resurgence with the purchase of ten properties on the street's east end, and the combination of historic facades, small businesses, luxury hotels, museums, and nightclubs and restaurants has Houston again looking like a street for all people.

MAJESTIC THEATER *p. 96*

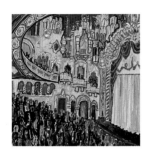

The outdoor ticket kiosk of the Majestic Theater takes the form of a Moorish pavilion and provides a hint of the inspired village scene that waits inside. Designed by architect John Eberson as an "atmospheric theater," the building followed a concept from the 1920s: when you go into a theater, it should feel like you are leaving a building and entering a picturesque village plaza at twilight. Eberson's village, with its mix of Moorish and Spanish Revival styles, is clearly Mediterranean. Surface textures and colors are artfully contrived to produce a soft, weathered appearance. The two sidewalls are elaborately decorated, though entirely different in design. The east side is an ancient baroque castle scene, and the west is dominated by a hillside village. Both reproductions feature an abundance of sculptural foliage, banners, even peacocks. Electric stars wink, and changing patterns of clouds drift above, all before you've found your seat. As the show begins, the lights dim in the plaster-vaulted "sky."

JAZZ'S ALIVE *p. 100*

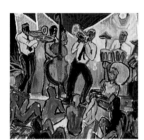

Every September, Travis Park comes alive with the call of a saxophone and the thump of a drum. Once home to legendary Texan Samuel Maverick, the land was deeded to the city in 1870 to create a park. In 1981 the San Antonio Parks Foundation was chartered to raise funds to improve the city's parks. The foundation's restoration of Travis Park was completed in 1984, and its reopening was celebrated with Jazz'SAlive. Twenty years later, this weekend celebration of jazz brings Grammy Award–winning jazz artists and a long list of other talented performers to this shady block in the middle of downtown.

MUNICIPAL AUDITORIUM *p. 101*

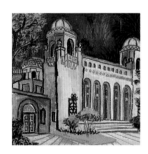

Designed by prominent San Antonio architect Atlee B. Ayres in the 1920s, and later dedicated to those who died in World War Two, the San Antonio Municipal Auditorium cost $1.2 million to build. The opening event in the stately auditorium was the Pioneer Ball, given by the State Association of Texas Pioneers. During the ball, no dancing was permitted until the auditorium's stage effects could be demonstrated. These included an asbestos curtain depicting the settlement of San Antonio in 1718, painted by Hugo Pohl and featuring the Franciscan fathers, Native Americans, a loaded burro, cactus, and several stray dogs. It also contained the names of Travis, Bowie, Crockett, and Bonham, as well as the shields of Spain, Mexico, and Texas. Over the years the auditorium has showcased operas, musical comedies, high school graduations, funerals, and dance marathons. The twelve-sided oval dome sits regally on six acres of grounds, ready for whatever comes its way.

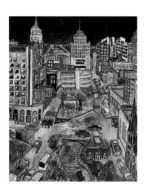

TRAFFIC PATTERNS *p. 105*

From the observation deck of the Tower of the Americas, you can't help but notice how San Antonio's streets zigzag out from the city center. It isn't until you reach the outer loops that streets run straight and square, as you would expect for a city this size. Many a visitor has cursed as a street turns one way and then makes a near U-turn before heading in a different direction. San Antonio is indeed a city built for horse rather than automobile. Routes still run along the original stagecoach and cattle trails, which often followed the Spanish irrigation ditches. Some streets, such as Navarro, cross the river three times.

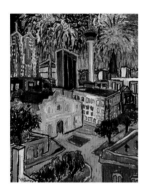

FIREWORKS OVER HEMISFAIR *p. 104*

At 750 feet, the Tower of the Americas was designed by architect O'Neil Ford as the focal point of HemisFair '68, the first official international exposition in the southwestern United States. The fluted concrete shaft with a revolving bar and restaurant on top beckons many to make the trip up in the tower's glass-faced elevator for a sunset cocktail or a 360-degree sightseeing adventure.

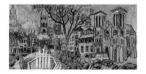

SAN FERNANDO CATHEDRAL *p. 106*

The Canary Islanders who came to this area in 1731 laid the cornerstone of the original San Fernando Cathedral seven years later. The walls of the church form the altar area of the present-day Gothic Revival sanctuary, completed in 1873. The oldest cathedral in the United States, San Fernando awed many an early visitor. According to *San Antonio Was,* in 1853 John Russell Bartlett made the observation, "The view of San Antonio from a distance is very beautiful. The place seems to be embowered in trees, above which the dome of the church swells with an air quite Oriental . . . The old church occupies its prominent position in the plaza." Today visitors are greeted by a $15 million facelift, completed in 2002. Pine pews that provided seating for eighty years have been restored, reworked, and replaced, and the 303-by-7-foot ceiling panels have been hand-stenciled and painted in twelve patterns.

CITY HALL *p. 111*

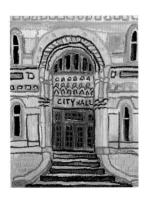

Early in the life of the city, Military Plaza, where the city hall resides, had a quieter atmosphere than neighboring Main Plaza. It was indeed a place where soldiers lived and drilled. During the Civil War, however, groups of vigilantes began to use the plaza for unofficial executions and lynchings. A priest had the trees cut down to stop the activity, but by then the plaza was one of the liveliest and sometimes most dangerous spots in town. On the northeast corner, on the ruins of the guardhouse of the old Spanish presidio, stood a forbidding building that served as the seat of government. Known as the "Old Bat Cave," in honor of the bats that lived in the walls and eaves and swarmed at dawn and dusk, it housed a courtroom upstairs and police headquarters downstairs. Business was so good that a jail was constructed nearby. The building meted out justice and occasional injustice until 1880, when it was torn down to make way for the new city hall. The ornate structure that replaced the Bat Cave in 1892 is grand and imposing. Designed by Otto Kramer and constructed of native limestone, the four graceful facades feature Corinthian columns of polished granite, a lofty dome, and a tower that provides excellent views of the city for those who make the climb.

SPANISH GOVERNOR'S PALACE *p. 115*

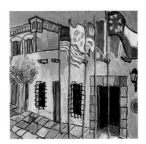

It was 1718 when Presidio de San Antonio de Bexar was established to protect the mission that served as fort and home to Spanish soldiers. Not far from the site of that mission, now known as the Alamo, is the presidio's one remaining structure, the Spanish Governor's Palace. A subtle whitewashed exterior belies the elegance of the interior, with its cobblestone patio, elegantly worn flagstone floors, and rich period furnishings. Were it not for the tenacity of Adina de Zavala, the early-twentieth-century preservationist who also saved the Alamo and four other San Antonio missions, the palace might be in a very different state. De Zavala, granddaughter of Lorenzo de Zavala, the first vice president of the Republic of Texas, once referred to the Spanish Governor's Palace as that "old relic of imperial Spain." And by the time Adina de Zavala came along, the palace was indeed an old relic, but any vestige of imperialism had long disappeared. The building had served as a Texian headquarters, fandango hall, bar, restaurant, schoolhouse, and secondhand clothing store. It was nearly crumbling. Rebuilding and restoration under the supervision of architect Harvey Smith took almost a year. Railroad ties replaced the original roof. Old telephone poles were converted into ceiling beams, and worn flagstones ripped from sidewalks became flooring pieces. Dedicated in March 1931, the palace was designated a Texas historic landmark in 1962 and a national historic landmark in 1970.

CONJUNTO PLAYERS *p. 114*

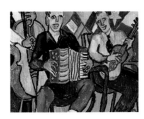

According to Juan Tejeda, former director of the Guadalupe Cultural Arts Center's Xicano music program and a San Antonio native, conjunto is "the original Tejano music created by Chicanos from Texas using a hybrid of influences." The most important influence is that of the button accordion, brought to the area by German, Czech, and Polish immigrants in the late 1800s. One story holds that Patricio Jimenez, grandfather of legendary Texas accordion player Flaco Jimenez, bought his first accordion in the early 1900s from a German in New Braunfels, and this cultural exchange began the famous Jimenez accordion tradition on San Antonio's west side. "We also adopted the rhythms that came along with the button accordion and made them our own, all the waltzes and polkas," Tejeda says. "Besides that, it was relatively cheap and one person could accompany himself." These days "conjunto" refers to the group or ensemble—in most cases a button accordion, bajo sexto, electric bass, and dance band drum set—as well as the music these groups play. The Tejano Conjunto Festival, which Tejeda began, continues to draw thousands of music lovers from around the world to Rosedale Park each spring.

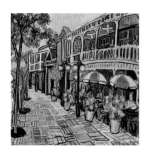

EL MERCADO *p. 116*

Free enterprise has a long history in the block today bounded by Interstate 35 and Houston, Buena Vista, and Santa Rosa Streets. Fruits and vegetables were first sold from individual carts in 1922, and El Mercado opened in 1954 when farmer Tobian Ybarra sold a bean pot to merchant Hilario Reyes for a quarter. Now known as Market Square, the area is a million-dollar business and a popular attraction. Some three million tourists visit the square each year seeking fresh produce, spices, pottery, and Mexican curios. There are woven *huipiles,* tortilla presses, and oilcloth, as well as silver jewelry and leather products. After all the shopping, a pan dulce and hot chocolate at the legendary Mi Tierra restaurant provides a sweet revitalization.

DAYS OF THE DEAD *p. 118*

Come late October and early November, San Fernando Cemetery No. 2 on Castroville Road explodes with eye-popping displays of flower vendors hawking wares of every possible color and texture. Fresh zinnias, marigolds, bright red cockscomb, and miniature yellow and purple poms are lined up alongside artificial arrangements of all sizes. This brilliant display is preparation for All Saints Day, which honors the lives of children on November 1, and El Día de los Muertos, or All Souls Day, which honors the remembrance of family members and friends on November 2. During the Days of the Dead, the cemetery transforms from a village of the dead to a bustling city of the living—up to 30,000 of them—whose cars and trucks fill the small roads. The days are spent telling stories, eating together, and tidying up the graves.

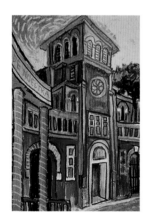

OUR LADY OF GUADALUPE CHURCH *p. 121*

Remember the reports of the Virgin Mary's image reflected off the chrome bumper of a car on San Antonio's west side? Or the story about the weeping Mary statue in a small church in Blanco? In South Texas, the miracle of Mary, better known as Nuestra Señora de Guadalupe, abounds. Our Lady of Guadalupe first appeared in the sixteenth century to Juan Diego, an Indian peasant, during a three-day period on the hill of Tepeyac, just outside Mexico City. Also a popular Hispanic cultural icon, she's frequently seen on T-shirts, bumper stickers, and biceps—and on a ceramic tile mural that faces Guadalupe Street. A block behind the mural is Our Lady of Guadalupe Church. In June 1992, another miracle is said to have taken place here. Hundreds of pilgrims, clutching candles and camcorders, lined up to see the tears from the parish's icon of the virgin. Official sanction as a miracle by the church was unclear, but belief was not. Some claimed the virgin was crying about gang violence in San Antonio. Others said it was for the state of the world. Others sold snow cones to the 5,000 people who waited in line each day during that steamy miracle week.

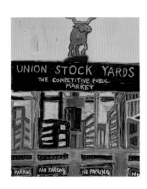

UNION STOCK YARDS *p. 125*

From opening day in 1889 to the last call in 2001, little changed with the look of the Union Stock Yards. The 112-year-old livestock market, with its cavernous auction room, steel gangway running over the cattle pens, and smoky commission office across the street in the Exchange Building, was Texas's last big-city stockyard. During its heyday in the 1950s, Union Stock Yards was a transit point for a million head of cattle, hogs, sheep, and goats a year. Now more of an industrial park than a cattle crossroads, the property's thirty-four acres are covered with buildings rented to small businesses. A huge Longhorn steer dappled in orange and white with a thirteen-foot "horn span" oversees the comings and goings.

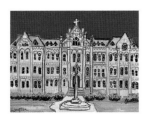

ST. MARY'S UNIVERSITY *p. 124*

The cream-colored Administration Building of St. Mary's University, designed by James Wahrenberger, was built far out on the city's west side in 1894 to house the students of overcrowded St. Mary's College, located on the river where La Mansion del Rio Hotel now stands. The university was started by three French Brothers of the Society of Mary, who began their teaching efforts in 1882 in a room over a livery stable on the west side of Military Plaza. Their determination blossomed into a 135-acre campus that today serves over 4,000 graduate and undergraduate students.

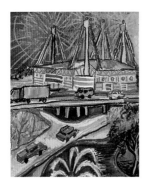

ALAMODOME *p. 127*

Completed in May 1993 through the support of citizens at a cost of $186 million, the Alamodome opened debt-free and is owned and operated by the City of San Antonio. Long the site for an eclectic group of sporting events, from monster truck shows to the NBA finals, it's also the home of college football's Alamo Bowl. The dome has been the site of NCAA basketball regional games and the Final Four, figure-skating exhibitions, boxing matches, concerts, conventions, and graduations. From 1999 to 2002 it was home to the San Antonio Spurs. Spurs fans know it best as the site of the 1999 "Memorial Day Miracle," when the team was playing the Portland Trail Blazers in Game 2 of the Western Conference finals. With nine seconds left in the game, Portland led by two. The ball went to Sean Elliott, who was almost out of bounds on the side of the court. He stood on his tiptoes above the sideline and hit a three-pointer that clinched the game and spurred the team toward its first NBA title.

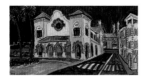

SUNSET STATION EXTERIOR *p. 128*

Located downtown, just east of I-37, are St. Paul's Square and the Southern Pacific Depot. In the mid-1800s, San Antonio was the only major city in the country without rail service. Mule trains utilizing as many as 330 mules per train of carts regularly traveled the streets. Then, on February 19, 1877, the Galveston, Harrisburg, and San Antonio Railroad established a depot at the foot of the hill below Fort Sam Houston, then known as Rattlesnake Hill. The Southern Pacific Railroad built a new station on East Commerce in 1903, and residential development shifted south and east. The Southern Pacific Depot was built of brick on a concrete foundation, with a red clay roof. The waiting room was lit with some 500 incandescent electric lights distributed on arches and panels and around two stained-glass rose windows. Additional lighting was by combination of gas and electric fixtures. During the first few years, the building became known as the "house of 1,000 lights." The depot is often called Sunset Station for the famous Sunset Limited train route across the south from California to Florida. With the arrival of the new station, the surrounding area became a busy commercial district. Most of the buildings, constructed between 1900 and 1920, housed hotels, saloons, nightclubs, retail stores, and boardinghouses. The area was named St. Paul's Square after St. Paul's Methodist Church on Center Street. The first train into the station carried "distinguished Boer visitors from South Africa." A relay team from Mexico comprised of Tarahumara Indians arrived on March 22, 1927, to compete in a University of Texas track meet. The Indians, known for their endurance running, went to visit the meet site, returned to San Antonio, and then ran the eighty-two miles to Austin to compete.

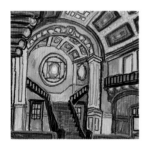

SUNSET STATION INTERIOR *p. 130*

The beautiful Spanish Renaissance–style Southern Pacific Depot, erected in 1903 on the east side of downtown, reflects the elegance of the early days of rail travel. The Beaux Arts interior features a carved oak-beam, barrel-vault ceiling, as well as art-glass windows and a large skylight.

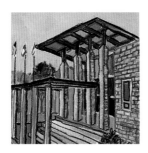

CARVER ACADEMY *p. 132*

The story of the Carver is nearly a century old. From 1905 to 1929 a Colored Library Association organized by east side civic leaders provided library services for the African American community with help from the city's library board. In 1919, the association received the support of the War Services Board to replace the wood frame structure with a larger assembly building. In the early 1920s, the City of San Antonio retired the outstanding notes on the property and became the owner. Then in 1929 the old buildings were demolished and a new structure, named the Carver Library Auditorium, was funded by a $75,000 city bond appropriation. Nearly every elderly eastsider has a story about the auditorium. Henrietta Stevenson remembers her kindergarten graduation and watching in awe as an older cousin went off to a dance. Joyce Sowells met her husband on the stage at one of the Carver's many fashion shows. "It is a real love story, the Carver and me," she says. In addition to holding community events of all kinds, the Carver was a stop on the "chitlin circuit," a semiofficial name for the tour of clubs, churches, and community centers that African American entertainers played during segregation. According to Bernice Williams, who included the Carver in a project on lost jazz shrines, performers such as Etta James, Redd Foxx, Gatemouth Brown, Duke Ellington, Charlie Parker, Count Basie, and many others regularly played at the Carver. Many of these performers played whites-only shows at the Majestic Theater or other venues and then jammed after hours in black clubs. In 1997, the Carver development board announced plans for the Carver Complex. The $12 million plan is anchored by a $5 million commitment from former San Antonio Spurs center David Robinson and his wife through the David M. Robinson Foundation. The complex includes the Carver Academy, a privately financed and governed school for 220 children; the Little Carver Civic Center, housed in Porter Memorial Church; new facilities for the Carver School of Visual and Performing Arts; a renovated Carver Center; and rehabilitated housing in the area. Indeed, Robinson's gift has sparked interest in the housing stock and other abandoned properties, including a plan to renovate the 472,000-square-foot Friedrich Air Conditioning factory building.

SBC CENTER *p. 134*

While San Antonio's SBC Center is dedicated to the art of the pick-and-roll and the craft of a last-second three-pointer, it also features an impressive array of work by visual artists. Spurs chairman and CEO Peter Holt's commitment to public art has made the center one of the most attractive arenas in the country. In the *San Antonio Express-News*, Holt commented, "I don't know where it says that people who go to sports events don't like art. . . . The guy sitting in the $10 seat is going to have art he can enjoy just as much as the guy sitting in the $1,000 seat." More than $1 million in public art projects by South Texas artists were commissioned for the SBC Center. Along with the original art, artworks and artifacts will be on loan from SBC's corporate collection, the Witte Museum, the Little Boot Co., and the photography archives of the Institute of Texan Cultures. Two highlights are George Cisneros's thirty-one-foot-long, neon-lit "Atomic Spur" suspended over the food court and Kathleen Trenchard's fifteen-foot-tall, colorful Mexican *papel picado* banners depicting San Antonio's landmarks and popular events.

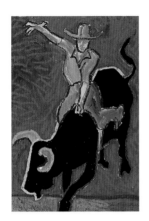

STOCK SHOW AND RODEO *p. 136*

April showers in Texas may or may not bring May flowers, but in San Antonio, February brings more boots, Stetsons, spurs, and Western shirts than any other month. It's Stock Show and Rodeo time, so stop and smell the—well, maybe not. But there is much to see. The forerunner to the ten-day February event began in March 1928 and was called the International Exposition and Livestock Show. It featured more cows and less two-stepping and sequins than the current music, food, and bronco-busting extravaganza. The Joe and Harry Freeman Coliseum became the venue for the full-on country-and-western showcase after its completion in 1949. All the real cowboys and cowgirls and plenty of wannabes show up to see top-notch entertainers, bucking broncos, snorting bulls, and very fast clowns on the midway.

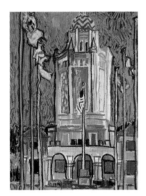

TAJ MAJAL, RANDOLPH AIR FORCE BASE *p. 138*

Building 100 at Randolph Air Force Base may be the Air Force's most recognizable structure. Presently home to the headquarters of the 12th Flying Training Wing, the majestic domed structure rises 170 feet above Washington Circle. No one knows who first dubbed it the Taj Mahal, but the name stuck. First Lt. Harold L. Clark, the architect of Randolph Field, envisioned the structure and devised a scheme to centralize a number of functions in a single, large post administration building at the base of the tower. Clark's sketches were carried out by the San Antonio architectural firm Ayres and Ayres, which designed such landmarks as the Municipal Auditorium, the McNay Art Institute, the Tower Life Building, and the St. Anthony Hotel. Their work, completed in 1931 at a cost of $252,000, resulted in a two-story Spanish Colonial Revival–style building capped by a blue and gold mosaic dome roof covered in ceramic tiles. Over its lifetime, the "Taj" has housed a 500,000-gallon water tank, the signal office, a photographic unit, the post office, the telephone exchange, a print plant, a weather office, the judge advocate's office and courtroom, the quartermaster's administrative offices, and the personnel, finance, recruiting, and public relations offices. In addition, the rear wing contained a movie theater and auditorium that seated 1,150. The building is the centerpiece of the Randolph Field Historic District, which was named a national historic landmark in August 2001.

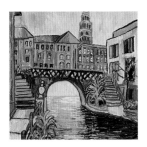

BEXAR COUNTY COURTHOUSE *p. 141*

A striking combination of granite and Pecos sandstone, James Riely Gordon's deep red Romanesque Bexar County Courthouse would turn heads even without its seven-story beehive tower. The so-called "beehive building" on Main Plaza was completed in 1896, and although there is no honey in the walls, there was once a box of memories. On December 17, 1892, according to newspaper records, a pair of stonemasons interred a time capsule in the cornerstone on the building's northeast side. The capsule included the courthouse dedication ceremony program and a list of county officers, Masonic lodge members, and people who attended the dedication, as well as Masonic lodge records, several copies of the *San Antonio Daily Express* and *San Antonio Evening News*, and eight pieces of Linotype. Jump forward to 1992 and preparations for the courthouse's 100-year anniversary. The only problem was that no one could seem to find the capsule. Bexar County commissioners thought the box was tucked into the cornerstone and even hired an architectural firm to x-ray the granite. The probe, however, revealed that the cornerstone was solid. A second X ray was done of the foundation below to see if the long-dead masons had buried the capsule there. Eventually laborers removed the entire 2,600-pound cornerstone. It was hollow as first reported, and the elusive box was inside. The old tin box was opened 100 years to the day from its interment, on December 17, 1992. Unfortunately the contents were a disappointment. Some of the newspapers were still intact, along with chunks of the lead Linotype and some old coins. Bits of the Masonic lodge documents were still legible. Everything else, however, had deteriorated beyond recognition, apparently because the bottom of the box had rusted. After the celebration, the cornerstone was relaid with only twentieth-century air inside.

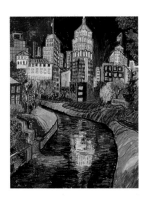

SOUTH RIVER WALK *p. 142*

Standing on the bridge that stretches above the waterfall on the south end of the River Walk, you can hear the rushing water, which seems to echo the sounds of laughter and chatter from the restaurants and stores upstream. But the entertainment down here is of a different speed and volume. Stands of native grasses bow in the wind as a mother duck leads her five handfuls of yellow fluff in a slow circle. Dog tongues and tails wag in time. The ripples from a skipped stone expand. This is the river in slow motion, a place for walks, for sitting and napping, for picnics and cloud watching. Nestled in the historic King William neighborhood, this southern stretch of the River Walk begins the water's winding journey farther south along its original path through the Spanish missions. On the way it will pass the Pioneer Flour Mills, where industrious German settlers made large-quantity flour production possible and inadvertently helped "invent" the flour tortilla as a South Texas staple. The ducks like to eat them, too.

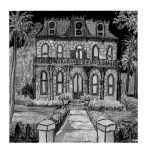

STEVES HOMESTEAD *p. 146*

The elegant Victorian home of the Edward Steves family at 509 King William Street was completed around 1878 in the German district known as "Sauerkraut Bend." An excellent example of Victorian French Second Empire design, the building is constructed of smooth-dressed ashlar limestone. After emigrating from Germany in 1848, Steves became a civic leader and was the proprietor of a successful lumber business. Donated to the Conservation Society in 1953 by the granddaughter of the original owner, the home is open to the public. Thirteen-inch limestone walls, imported mahogany and native walnut woodwork, gracious arches with pierced woodwork details across the porch, and rooms filled with Victorian antiques make this home a special visit.

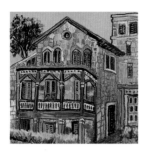

WULFF HOUSE *p. 147*

Entering the King William neighborhood from St. Mary's Street, the first house you come to on the right has a unique square tower. Built in the 1870s by Anton Frederick Wulff, who in the 1890s landscaped Alamo Plaza, the house features Italianate style and asymmetrical design. After the Wulff family, it was the home of the Arthur William Guenther family and was then turned into apartments. In about 1904 it was purchased by the United Brotherhood of Carpenters and Joiners, who sold the property to the San Antonio Conservation Society in 1974. After a year of restoration it became the headquarters of the society and home to its outstanding local history library.

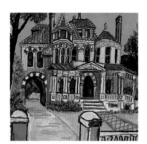

KING WILLIAM RESIDENCE *p. 148*

According to Mary Burkholder's *The King William Area: A History and Guide to the Houses*, "In 1868 when John and Joseph Ball bought the lots which are now 116 and 120 King William Street from Phoebe Grossbeck, the street in front of their property was not yet named. It is said that Ernst Altgelt gave King William Street its name in honor of the Prussian ruler Wilhelm I. For a time around World War I, the City Directory shows the street as Pershing Avenue." When the Germans again became U.S. allies, the street was again called King William Street. The King William neighborhood, now protected by national, state, and city historic designations, has a range of unique architectural influences from limestone cottages, to ornate Victorian gingerbread-trimmed structures, to Greek Revival mansions and smaller wood frame dwellings. Known as one of San Antonio's most eclectic neighborhoods, the area features crape myrtle–lined streets that are ideal for strolling. Maps are available at the Wulff House, 107 King William Street.

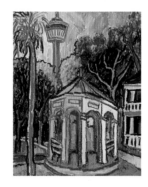

KING WILLIAM GAZEBO *p. 150*

The gazebo in King William Park was originally situated on the grounds of the United States Arsenal on Arsenal Street and was most likely built sometime in the 1860s. In 1954, it was moved to King William Park through the efforts of the King William Area Conservation Association. If you stand in the gazebo and turn in a circle, you'll catch a glimpse of the variety of architectural influences that make up this historic neighborhood. These include European, Greek Revival, Victorian, Neoclassical, and native Texas vernacular from the 1860s to the 1920s. Also reflected is the diversity of the population. On one side is a small indigenous cottage and on the other a Greek Revival mansion, while an Italianate house with a tower stands near Durango Street.

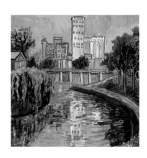

PIONEER FLOUR MILLS *p. 152*

When most people think of Tex-Mex food, they think of tortillas—not the thick hand-ground corn tortillas common in interior Mexico, but the white puffy flour variety. Indeed, these days flour tortillas are a staple throughout South Texas. But without the innovation of German immigrants such as Pioneer Flour Mills founder Carl Hilmar Guenther, the flour tortilla might never have gained such widespread popularity. Guenther founded the mill 155 years ago in Fredericksburg, Texas, and relocated to San Antonio before the Civil War because the San Antonio River offered more reliable water power. The mill's large-scale, steady production of wheat flour made the grain available for everyday foods like tortillas. Wheat and corn are still ground into flour at Pioneer's castle-like grain elevator, which overlooks the historic King William neighborhood.

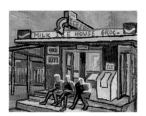

ICE HOUSE *p. 156*

A reporter from the *New York Times* once compared San Antonio ice houses to street cafes in Paris and coffeehouses in Vienna. A woman sipping espresso on a Paris corner might not see the commonality with the guys from the produce terminal gulping icy Lone Star beers to the sounds of Freddie Fender on a July afternoon, but the point is this: an ice house, like a cafe, is a place where people of every stripe sit, meet, and greet. Often thought of as a uniquely Tejano male stronghold, many ice houses, with outdoor picnic tables in the shade of pecan or live oak trees, attract families. When the early German settlers brought beer drinking to San Antonio in the mid-1880s, the unpasteurized brew depended on the availability of ice. In the 1900s, as the city grew, ice stations were established where ice could be stocked and neighborhood residents could buy fresh produce, milk, and ice-cooled beer. These ice houses, often situated near railroad crossings, became gathering places.

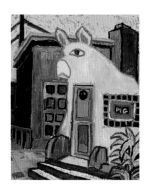

PIG STAND *p. 159*

The terms "curb service" and "carhop"—for the waiters who jumped onto running boards to take orders quickly—originated at the Pig Stand, which opened in Dallas in 1921. The Pig Stand also claims other firsts, including the first drive-in window and innovations such as fried onion rings, Texas toast, and the trademarked Pig Sandwich, "America's Motor Lunch." Its 1950s decor, classic-car nights, and trademark barbecued pork sandwich capture a certain bygone Texas that prompted author Larry McMurtry to use a Pig Stand as a setting in his novel *The Evening Star.* The original pig sits at the corner of South St. Mary's and Pereida Streets in Southtown, where he is regularly dressed up for the holidays.

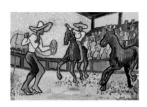

LA CHARREADA *p. 160*

Deep on the city's south side you can see Mexican *charros,* or expert horsemen, practice an art form and tradition that dates back to sixteenth-century Spain. Part artistry, part horsemanship, part competition, and wholly the preservation of a way of life, the Mexican sport is a tradition like no other. The San Antonio Charro Association has spent the last quarter-century preserving the glory of the sport. Inside small dusty arenas like the one on Mission Road, you can see contestants work ropes into flowers and do death leaps onto horses, all with pure elegance. Americo Garcia, a former competitor in *charreada* contests, explains, "You can trace every American rodeo back to the Mexican rodeo. . . . Our reasons for our sport are totally different from that of rodeo. It's not as fast as rodeo, but there's more artwork, more horsemanship. Our main goal has been to preserve a way of life."

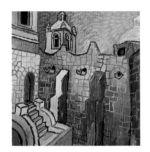

MISSION CONCEPCIÓN *p. 162*

Founded in 1716 in what is now East Texas, Mission Concepción was one of six missions developed by Franciscans to serve as a buffer against the threat of French incursion into Spanish territory from Louisiana. After a tenuous existence and several moves, the mission was transferred to its present site in 1731. The stone church, completed in 1755, appears much as it did over two centuries ago. It remains the least restored of the colonial structures within the San Antonio Missions National Historic Park. In its heyday, colorful geometric designs covered its surface, but the patterns have long since faded. While Concepción is the only mission in the park not to support an active congregation, masses are still occasionally celebrated and former members retain strong ties to the church.

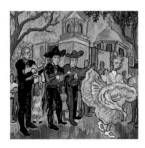

MARIACHI MASS *p. 166*

The Mission San José mariachi mass, conducted every Sunday at noon, brings a distinctly Mexican flavor to a traditional Catholic mass. There are no organs here. Trumpets, guitars, and lifting voices fill the air.

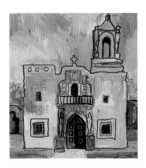

MISSION SAN JOSÉ *p. 168*

One year after Fray Antonio Margil de Jesús left the failed missions in East Texas, he founded what many called a model Texas mission. San José, which housed some 300 inhabitants and was sustained by extensive fields and livestock herds, also gained a reputation as a major social and cultural center. The rich enterprise became a natural target for mounted Apache and Comanche raiders. With technical help from the two or three presidial troops garrisoned in the area, San José residents learned to defend themselves. Although they could not prevent raids on their livestock, the mission itself was almost impregnable. In his journal, Fray Juan Agustín Morfi attested to its defensible character: "It is, in truth, the first mission in America . . . in point of beauty, plan, and strength . . . There is not a presidio along the entire frontier line that can compare with it."

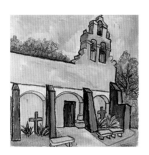

SAN JUAN CAPISTRANO *p. 172*

Originally founded in 1716 in East Texas, Mission San Juan was transferred in 1731 to its present location. There, the stone church, a friary, and a granary were completed, and by the mid-1700s San Juan, with its rich farm and pasturelands, was a regional supplier of agricultural produce. A truly self-sustaining community, the compound housed Indian artisans who produced iron tools, cloth, and prepared hides. Orchards and gardens outside the walls provided melons, pumpkins, grapes, and peppers. Beyond the compound, Indian farmers cultivated maize, beans, squash, sweet potatoes, and sugarcane in irrigated fields. The San Juan acequia is part of an irrigation system that has its roots in the ancient Middle East, Roman, and great Mesoamerican civilizations. This means of irrigation was adopted by later Anglo-American, German, and Italian settlers in South Texas and used into the late 1800s. San Juan, more than any other mission, is a testament to the often overlooked influence of Native Americans on the area's missions. In her book, *History and Legends of the Alamo and Other Missions in and around San Antonio*, Adina de Zavala writes, "The main buildings, unlike the main buildings of the Mission of the Alamo, Concepción, and San José, form part of and are built into the boundary or rampart walls. It is said that in the vicinity of San Juan Mission there are more traces of the Indian in features and characteristics than anywhere else in the interior of Texas."

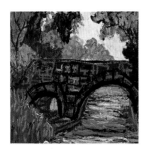

ESPADA AQUEDUCT *p. 175*

Completed in 1745, the Espada aqueduct carries water over Piedras Creek to fields near the missions, just as it did centuries ago. This feat of engineering is the only functioning aqueduct from the Spanish colonial period in the country. Using a system of floodgates, the ditch master controlled the volume of water sent to each field for irrigation and for bathing, washing, and power for mill wheels. Irrigation was so important to settlers that they measured cropland in *suertes*, the amount of land that could be watered in one day. During secularization of the land, inhabitants were given, for example, three days' water worth of land. Nearby farms still draw water from the system.

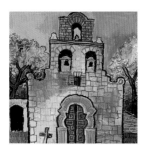

MISSION ESPADA *p. 176*

Mission San Francisco de la Espada was founded in 1690 as San Francisco de los Tejas near present-day Weches. The first mission settlement in Texas, Espada was transferred to the San Antonio River area and renamed in 1731. Following Spanish policy, Franciscan missionaries sought to make life within mission communities closely resemble that of Spanish villages. In order to become Spanish citizens and what the Spanish thought of as productive inhabitants of mission communities, Native Americans learned vocational skills. As plows, farm implements, and gear for horses, oxen, and mules fell into disrepair, iron-working skills became indispensable. As mission buildings became more elaborate, occupants learned masonry and carpentry skills under the direction of craftsmen contracted by the missionaries. After secularization, these skills proved beneficial to the postcolonial growth of San Antonio. The legacy of these Native American artisans is still evident in the work of San Antonio craftworkers today.

CREDITS

The publisher gratefully acknowledges the following for permission to reprint quoted material.

page 11
Domingo Terán de los Rios, 1691, *Report to the Viceroy of Mexico.*

pages 15, 39, 48, and 99
Collected Works of Sidney Lanier: Florida and Miscellaneous Prose, edited by Philip Graham (Baltimore, Maryland: Johns Hopkins University Press, 1945).

pages 16 and 93
By permission of the author, Jan Morris, 2004. From "Interstate 281," in *Granta* 10 (1984).

page 20
Charles Kuralt, CBS, 1990.

page 23
Richard Everett, "Things In and About San Antonio," in *Frank Leslie's Illustrated Newspaper,* 7 (Jan. 15, 1859).

page 27
Charles Ramsdell, *San Antonio: A Historical and Pictorial Guide, 2nd rev. ed.* (Austin: University of Texas Press, 1985).

page 35
George Bonnell, *Topographical Description of Texas* (Austin, Texas: Clark, Wing, and Brown, 1840).

page 43
By permission of the author, Rosemary Catacalos, 2004. From "Homesteaders: for the Edwards Aquifer," in *Again For the First Time* (Tooth of Time Books, 1984).

page 44
Stephen Crane in the West and Mexico, edited by Joseph Katz (Kent, Ohio: Kent State University Press, 1970).

pages 53 and 94
From *On the Road* by Jack Kerouac, copyright © 1955, 1957 by Jack Kerouac; renewed © 1983 by Stella Kerouac; renewed © 1985 by Stella Kerouac and Jan Kerouac. Used by permission of Viking Penguin, a division of Penguin Group (USA) Inc.

pages 54, 81, 87, 115, 129, 140, and 149
In Donald E. Everett, *San Antonio: A Flavor of Its Past* (San Antonio, Texas: Trinity University Press, 1976).

page 60
John Gunther, *Inside U.S.A.* (New York: Harper and Brothers, 1947).

page 64
T. R. Fehrenbach, in *Saving San Antonio: The Precarious Preservation of a Heritage,* by Lewis F. Fisher (Lubbock: Texas Tech University Press, 1996).

page 69
Bartlett Cocke, Report to the Special Campus Site and Planning Committee, Trinity University, July 11, 1944.

page 85
Claude Stanush, *The World in My Head* (Austin, Texas: Thorp Springs Press, 1984).

pages 89 and 105
In *San Antonio: The Story of an Enchanted City,* by Frank W. Jennings (San Antonio, Texas: San Antonio Express-News, 1998).

pages 90 and 167
Larry McMurtry, *In a Narrow Grave: Essays on Texas* (Austin, Texas: Encino Press, 1968). © 1968 by Larry McMurtry. Reprinted with permission of The Wylie Agency.

page 102
Graham Greene, *Another Mexico* (New York: Viking, 1962).

page 107
By permission of the author, Mary Ann Noonan Guerra, 2004. From *San Fernando: Heart of San Antonio* (San Antonio, Texas: Alamo Press, 1977).

page 109
Richard A. Garcia, *Rise of the Mexican American Middle Class: San Antonio, 1929–1941* (College Station: Texas A&M University Press, 1991).

page 112
From *Caramelo*. Copyright © 2002 by Sandra Cisneros. Reprinted by permission of Susan Berholz Literary Services, New York. All rights reserved.

page 117
Marian Haddad, unpublished memoir, 2002.

pages 119, 173, and 177
From *Places Unfinished at the Time of Creation* by John Phillip Santos, copyright © 1999 by John Phillip Santos. Used by permission of Viking Penguin, a division of Penguin Group (USA) Inc.

page 120
Oscar Wilde Discovers America, by Lloyd Lewis and Henry J. Smith (New York: Benjamin Blom, 1936).

page 155
"David Robinson, NBA Legend." *Parks and Recreation* (July 2003).

page 159
Green Peyton, *San Antonio: City in the Sun* (New York: McGraw-Hill Book Company, Inc., 1946).

page 143
By permission of Red McCombs, 2004. From *Sports Illustrated*, December 9, 2003.

page 144
By permission of the author, Frank Jennings, 2004. From *San Antonio: The Story of an Enchanted City* (San Antonio, Texas: San Antonio Express-News, 1998).

page 155
Frederick Law Olmsted, *A Journey through Texas; or, A Saddle-Trip on the Southwestern Frontier; with a Statistical Appendix* (New York: Dix, Edwards and Co., 1857).

page 157
By permission of the author, Naomi Shihab Nye, 2004. From *Words under the Words* (Far Corner Books, Oregon), 1995.

pages 165 and 169
Capt. Frederick Marryat, *Travels and Adventures of Monsieur Violet in California, Sonora, and Western Texas* (London: George Routledge and Sons, 1900).

page 174
Stephen Brook, *Honkytonk Gelato: Travels Through Texas* (New York: Atheneum, 1985).

 William B. Thompson was born in Hudson, New York. He graduated from Trinity University in San Antonio, Texas, with a B.A. in history. While taking an art course, he received guidance from art professor Bill Bristow, who encouraged Thompson to continue his artistic development. Early shows and gallery exhibitions paid for Thompson's law degree, which he received from Campbell University. He has exhibited his paintings throughout the United States and the Caribbean, and his works are in corporate and private collections worldwide. He lives and paints in the Virgin Islands.